Albion, the ancient (Celtic or pre-Celtic) name for Britain, soon ousted by the Celtic 'Britannia'. The Romans connected it with *albus*, 'white', and referred it to the cliffs of Dover.

Oxford Companion to Classical Literature

1808, July 23. I left Town for Dover [on] the mail and arrived there the next morning. I walked about in Town and about evening wandered away to Shakespeare's clift; here perhaps, I said, Shakespeare has stood, here Lear defied the Storm, there, as I looked towards the Castle, Cordelia died; how many Kings of England have embarked from Dover to France? For the first time in my life I saw the white cliffs of England, beating back the murmuring surge, and as the Sun shot a last gleam athwart the ocean, I caught a glitter of the distant coast of France – how I felt. There, I thought, is France, the proud enemy of England.

Benjamin Robert Haydon, *Journal*, entry for 1808

[The] wide dispersal of the material for the history of British painting – assisted by our national apathy – is the reason for its neglect by serious students and for the backward state of our knowledge of it.

Ellis Waterhouse, *Painting in Britain 1530–1790* (1st edn, 1953)

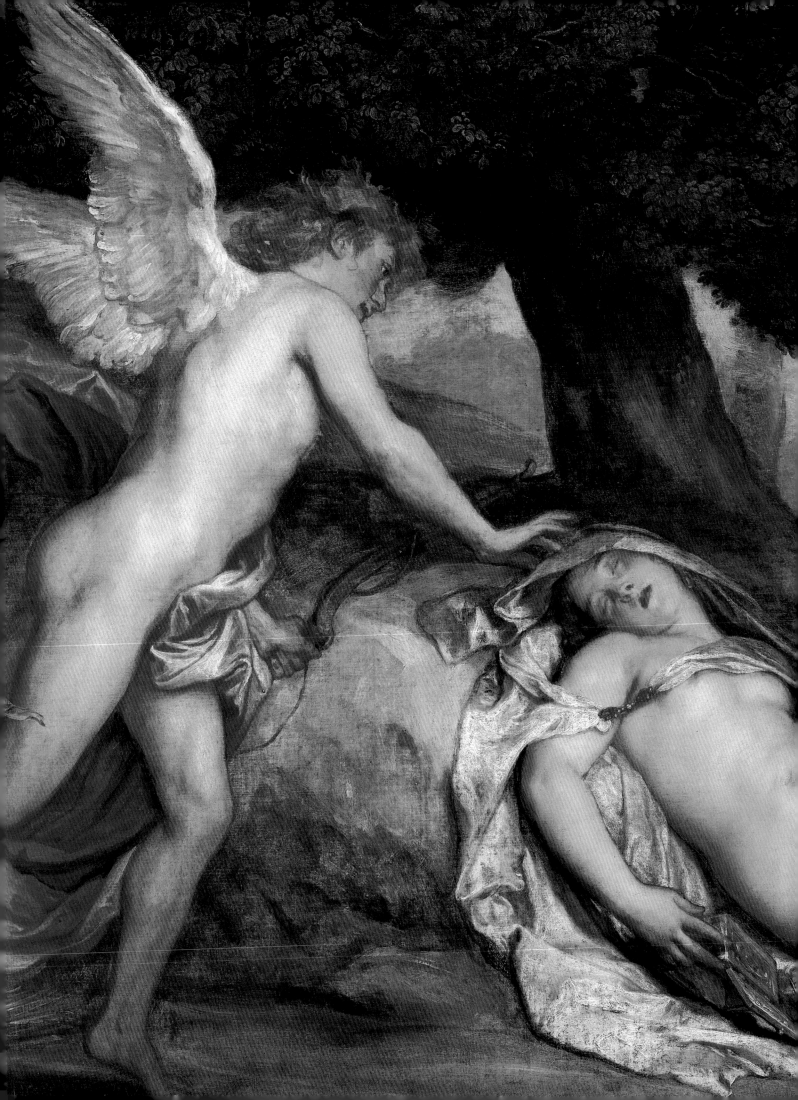

THE QUEST FOR ALBION

Monarchy and the Patronage of British Painting

Christopher Lloyd

with contributions by

Kathryn Barron

Charles Noble

Lucy Whitaker

THE ROYAL COLLECTION

First published 1998 by
Royal Collection Enterprises Limited,
St James's Palace, London SW1A 1JR

http://www.royal.gov.uk

ISBN 1-902163-14-1

A catalogue record for this book is
available from the British Library.

Produced in association with
Book Production Consultants plc,
Cambridge.

Designed and composed in Scala
and Scala Sans by Jeffery Design.
Printed and bound in Italy by
Grafiche Milani.

This publication accompanies an
exhibition held at The Queen's Gallery,
Buckingham Palace
(15th May–11th October 1998).

PHOTOGRAPHIC ACKNOWLEDGEMENTS
The authors and publisher are grateful
for permission to illustrate the
following items, which are not part of
the Royal Collection: fig. 2 is Crown
copyright: Historic Palaces; figs 3 and 4
are reproduced by permission of the
Trustees of the British Museum; fig. 10
is reproduced by courtesy of the
National Portrait Gallery, London.

Distributed by Thames and Hudson
Ltd, 30 Bloomsbury Street,
London WC1B 3QP

FRONT COVER
Sir Peter Lely, *Henrietta Boyle, Countess
of Rochester*, 1662–5. See page 40

BACK COVER
George Sanders, *George Gordon, Sixth
Lord Byron*, c. 1807–9. See page 80

FRONTISPIECE
Sir Anthony van Dyck, *Cupid and Psyche*
(detail), c. 1639–40. See page 34

CONTENTS

ACKNOWLEDGEMENTS

Since the mid-nineteenth century several of those responsible at various times in their careers for the paintings in the Royal Collection have made a contribution to the study of British painting. Richard Redgrave published, with his brother Samuel, *A Century of British Painters with critical notices of their works, and an account of the progress of art in England* in 1866; Lionel Cust wrote *Anthony van Dyck, An Historical Study of his Life and Works* (1900); and C. H. Collins Baker contributed *Lely and the Stuart Portrait Painters* (2 vols, 1912) – a publication that Sir Ellis Waterhouse described as having been 'effected with no greater aid to transportation than a bicycle'. Neither should it be forgotten that Waterhouse's own ground-breaking volume *Painting in Britain 1530–1790* (Pelican History of Art, 1st edn 1953) was dedicated to Collins Baker 'who first aroused in me an interest in British painting'.

Yet, the greatest contribution has been made by my immediate predecessor, Sir Oliver Millar, who is not only an authority on Van Dyck and seventeenth-century British painting generally, but has in addition catalogued the entire collection of British pictures until the death of Queen Victoria in three separate volumes (1963, 1969 and 1992). The present undertaking is not to be directly compared with the achievements of these forerunners as it differs in purpose and scope, but it is, none the less, indebted to their scholarship and insights. A glance at the list of titles under 'Further reading' will reveal some other recent sources for the introductory essay.

The text accompanying this selection of forty-six paintings has been written by my colleagues Lucy Whitaker (L.W.), Assistant to the Surveyor of The Queen's Pictures; Kathryn Barron (K.B.), Loans Officer and Assistant Curator of Paintings; and Charles Noble (C.N.), formerly Assistant to the Surveyor of The Queen's Pictures and now Assistant Keeper of Collections at Chatsworth. The authors would like to thank the following for advice and information: Martin Bailey, Margaret Bent, Lieutenant Commander J. B. Claro, Jane Garnett, Martha Klein, Hélène La Rue, Catharine MacLeod, Kenneth McConkey, Olivier Meslay, Mike Moody, Harry Mount, Virginia Murray, Christiana Payne, Jane Sellars, Laura Tayler, Richard Woodman. Lucy Whitaker would particularly like to thank Annette Peach and Fiona MacCarthy for allowing her to draw on their unpublished research on Byron.

C.L.

PREFACE

The holding of British paintings in the Royal Collection is extensive and important. Gathered over several centuries, partly on an official basis and partly as a result of the personal taste of monarchs, the British pictures are wide ranging although not comprehensive. They have in recent years been carefully catalogued, but even so remain relatively unknown. Unlike those of a major art gallery, the paintings in the Royal Collection are distributed between several royal residences and so the impact of a single artist or, as in this case, of a single school, is somewhat dissipated.

The present publication is conceived as an anthology of British paintings in the Royal Collection. Not all will be familiar, but some are masterpieces. The selection, however, has a further purpose and that is to see the paintings in the context of the national heritage. Viewed in this light, it can be argued that these pictures have played a significant, and as yet perhaps not fully recognised, role in the development of a national school of painting. This is even more the case when it is recalled that George III was the first Patron of the Royal Academy, founded in 1768, or that Prince Albert was made President of the Fine Arts Commissioners in 1841. Even more pertinent is the fact that formal recognition of a British School in a museological sense during the nineteenth and twentieth centuries was subject to confusion and obfuscation. Indeed, only now does a solution to that problem seem to be approaching with the rearrangement of the Tate Gallery.

The world-wide success of contemporary British painting (using the widest chronological span) has to a certain extent generated increasing interest in the origins and development of the British School. The world of scholarship in its recent interdisciplinary mode has become fascinated by topics arising from the study of British art of all centuries. New ideas, books and articles written from both traditionalist and post-modernist viewpoints have created a state of constant reassessment. *The Quest for Albion: Monarchy and the Patronage of British Painting* is a response and, it is hoped, a contribution to this visual and intellectual refulgence.

C.L.

Monarchy, Politics and Patronage

Christopher Lloyd

A discussion of the relationship between British monarchs and the development of a national school of painting might at the outset seem somewhat contrived. On an objective basis any list of the artists they patronised can hardly be described as comprehensive; the support given to those institutions such as the Royal Academy with which they are officially associated has on the whole been episodic; and their retention of interest in matters concerning art has at best been spasmodic. Yet, it would be wrong to underestimate the contribution played by monarchs in the growth of the British School. The institution of monarchy itself has from the sixteenth century at least had a defining role in the establishment of national identity in the political sense and this by extension can also be applied in the cultural context. Indeed, these two aspects became inextricably linked because royal patronage was essentially governed by two important factors – political circumstances and personal taste.

For more than half its history British art was closely related to that of mainland Europe. There was a marked dependency on foreign artists that remained prevalent during the Tudor and Stuart dynasties when the distinction between public and private patronage was blurred, partly as a matter of policy and partly owing to the formalities of the court. The dearth of indigenous talent thwarted the growth of a national school of painting that only became possible during the eighteenth century. The iconographical requirements of the Tudors, therefore, found expression in the images created by the German artist Hans Holbein the Younger as in the Whitehall Mural of 1537 (fig. 1). The Stuarts perfected the same practice, albeit on a more elaborate scale. For the absolutist regimes of the seventeenth century the Baroque style, filling wide open spaces with rhetorical flourishes and extensive casts of allegorical figures, was an ideal instrument for political statements. It was for such reasons that Charles I commissioned Sir Peter Paul Rubens to paint the ceiling of the Banqueting House at Whitehall Palace in honour of his father, James I (fig. 2). The Banqueting House (1619–22) was designed by Inigo Jones and the decorative scheme for the ceiling was inspired predominantly by Venetian practices. The purpose was to commemorate the beneficent rule of James I. The three main compartments depicted the 'Apotheosis of James I' (centre), the 'Benevolent Government of James I' (south) and the 'Union of England and Scotland' (north). The ovals in the corners celebrated the virtues of the King (Liberality, Reason, Heroism and Wisdom), whilst in the border friezes of putti symbolised Peace and Plenty. Politically, therefore, the ceiling of the Banqueting House was propagandist and the choice of Europe's leading exponent in this field to carry

Detail from Benjamin West (1728–1820), *The Departure of Regulus*, 1769. See page 72

out the work resulted in 'the greatest decorative paintings ever executed for an English interior' (Edward Croft-Murray).

The talent at the disposal of Charles I was not available during the reign of his successor. Furthermore, the middle decades of the seventeenth century were punctuated by political upheaval. The Civil War had culminated in the beheading of Charles I in 1649 and was followed by the establishment of the Protectorate, which was in turn brought to a close by the Restoration of 1660. Charles II looked to France rather than to Flanders for his inspiration and sought to emulate Louis XIV, although he lacked comparable financial means and needed to demonstrate a greater awareness of any political consequences resulting from his actions. His chosen artist, the Italian Antonio Verrio, decorated numerous rooms in Windsor Castle between *c.*1675 and *c.*1684. Only one of the ceilings in the King's Apartments and two of those in the Queen's Apartments survive intact today, but the mere titles of those in the King's Apartments that were destroyed during the 1830s at the behest of William IV make Charles II's purpose clear: the 'Restoration of the Church of England' and 'Charles Enthroned with a Personification of France at his Feet' are typical examples. Verrio was a routine, but effective and richly remunerated painter. He continued to find favour in the reign of Queen Anne, for whom after 1700 he painted several rooms in Hampton Court Palace. These include the Queen's Drawing Room, where his murals, designed to resemble tapestries, comprise four compositions symbolising British marine power, as in 'Britannia Receiving the Homage of the Four Continents'.

Figure 1 Remigius van Leemput (d. 1675), *Henry VII, Elizabeth of York, Henry VIII and Jane Seymour.* Oil on canvas. 88.9 × 98.7 cm. Royal Collection (Hampton Court Palace)

A reduced copy after the life-size composition painted for Henry VIII in 1537 by Hans Holbein the Younger. The original mural was apparently painted on the wall of the Privy Chamber in Whitehall Palace and was destroyed in the fire of 1698, although vigorous attempts were made to save it. Holbein stresses the dynastic aspirations of the Tudors and the inscription extols the political virtues of Henry VII and Henry VIII. The decorative motifs of the interior are Renaissance in style and attest the innovative aspects of Holbein's style in England. The copy was made for Charles II.

Figure 2 (opposite) Sir Peter Paul Rubens (1577–1640), The Ceiling of the Banqueting House, Whitehall Palace, London

The Banqueting House is the only surviving part of Whitehall Palace and was designed by Inigo Jones in a classical style. Rubens was commissioned by Charles I *c.* 1630 to decorate the interior, and the nine compartments of the ceiling were finished *c.* 1634. The theme is the glorification of James I and by extension the reign of his son. Rubens by this stage of his career was much practised at devising political allegories of this type, but the ceiling is the only remaining decorative scheme by the artist still in its original setting. The Banqueting House was used primarily for ceremonial occasions, such as the annual procession of the Order of the Garter, and also for masques. After Rubens's ceiling was unveiled Charles I forbade the performance of masques for three years 'lest this might suffer by the smoke of many lights'.

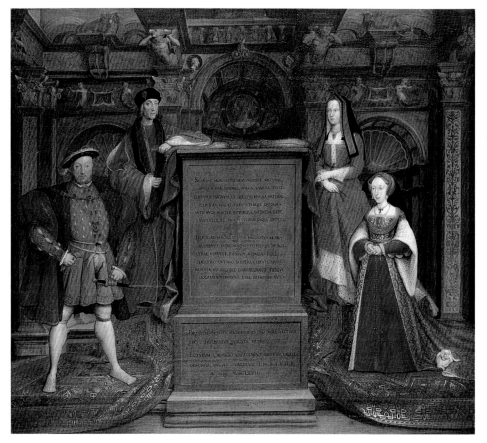

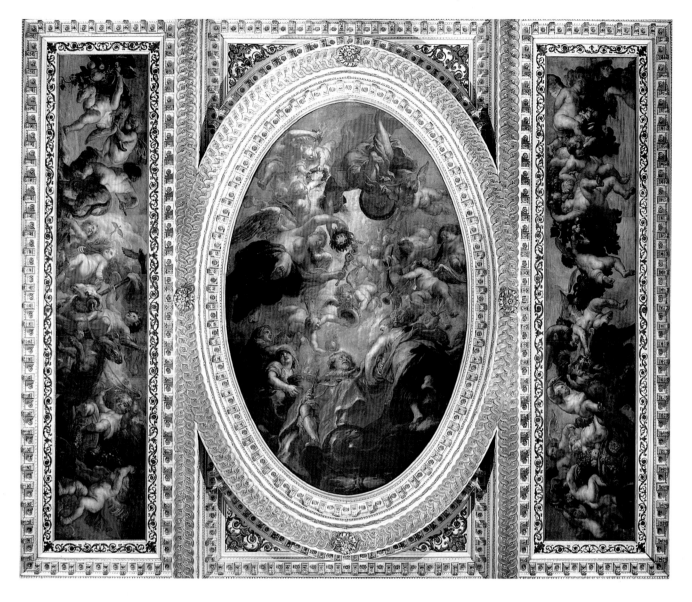

Verrio died at Hampton Court Palace in 1707, but the Baroque tradition was brought to a magnificent climax by his erstwhile pupil, Sir James Thornhill – the first British-born painter to be knighted. Thornhill's masterpiece was the decorative scheme he devised for the Upper and Lower Hall and Vestibule at Greenwich Naval Hospital, founded by William III and Mary II and built by Sir Christopher Wren (from 1696). In these wide spaces and over a period of twenty years Thornhill painted homages to William III and Mary II, Queen Anne and Prince George of Denmark, and finally to George I. The Lower (or Great) Hall was completed (1707–14) first with the 'Glorification of William III and Mary II Giving Peace and Liberty to Europe' covering an area of some 510 sq m (5,500 sq ft) and in this respect comparable with churches in Rome of the same period. The Upper Hall has in turn been described as 'the most complete realisation of Baroque iconography in an English interior' (Edward Croft-Murray). The ceiling portrays Queen Anne and Prince George of Denmark, but with the advent of the Hanoverian dynasty the emphasis changed to George I.

The scene of the arrival of the King and his family at Greenwich in 1714 (on the north wall) was balanced by a reference back to the landing of William III at Torbay in 1688 (on the south wall). The other two walls in the Upper Hall comprise a group portrait of the family of George I opposite allegories on *Salus Publica* and *Securitas*. Ultimately, the scheme was intended to illustrate the triumph of the Protestant succession in England.

Thornhill's work at Greenwich marks the end of a tradition. He himself acknowledged the difficulties of such historical representations in two compositional drawings (both in the British Museum) made in connection with *George I Landing at Greenwich* (figs 3–4). The extensive annotations on the first drawing are headed, 'Objections y^t will arise from y^e plain representation of y^e K. Landing 7^br [September] 18^th 1714 as it was in fact, & in y^e modern way & dress'. He then considers such issues as the time of day, the size of the crowd and the identification of those in attendance on the King. The artist ponders the advantages and disadvantages of rendering these aspects of the composition accurately with a view to recording historical truth. The second drawing, however, reveals that Thornhill decided to reject any such literal representation for the more traditional allegorical treatment.

Such solutions – indeed such subject-matter – could not be sustained in the eighteenth century, although distant echoes of this defunct tradition can be found in the work of Benjamin West, in the various schemes to complete the interior decoration of St Paul's Cathedral and, even more rarely, during the reign of Queen Victoria. West's painting entitled *The Recovery of His Majesty in the Year 1789* (fig. 5) celebrates the resumption of power following George III's first attack of apparent insanity. The composition is replete with symbolic overtones and elaborate inscriptions as the King, accompanied by Queen Charlotte, strides towards the leaders of the government, indicating that the political crisis has passed. Shortly before this West had devised a decorative scheme for the Queen's Lodge situated on the south side of Windsor Castle. With the help of the architect Sir William Chambers, the Queen's Lodge was extended between 1778 and 1782 for temporary use by the royal family, but it was demolished by

Figure 3 (below left) Sir James Thornhill (1675/6–1734), *George I Landing at Greenwich in 1714*. Pen and brown ink with brown-grey wash over black lead. 158 × 228 mm. British Museum, Department of Prints and Drawings (1865.6.10.1327)

This elaborate study was made for the painting on the north wall of the Upper Hall at Greenwich Naval Hospital. The decorative scheme in the Upper Hall was completed in 1726. The extensive annotations reveal Thornhill's concern with the degree of visual accuracy he should bring when depicting the scene as it was witnessed in 1714. He lists five such points in the left margin, involving the time of day, details of dress and the identifications of those present, and writes out his solutions in the right margin.

Figure 4 (below right) Sir James Thornhill (1675/6–1734), *George I Landing at Greenwich in 1714*. Pen and brown ink with brown-grey wash over black lead. 175 × 228 mm. British Museum, Department of Prints and Drawings (1865.6.10.1353)

Having explored the possibilities of a realistic depiction of the events of 1714, Thornhill here proposes an alternative composition in which allegory is dominant.

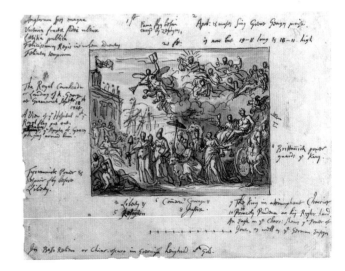

MONARCHY, POLITICS AND PATRONAGE

Figure 5 Benjamin West
(1738–1820), *The Recovery of His
Majesty in the Year 1789*.
Oil on canvas. 52 × 77 cm. New
York, Collection of Hirschl & Adler
Galleries

George III's first attack of what is now identified as porphyria occurred in the autumn of 1788. He recovered in March 1789 and opened Parliament in that month. This painting represents public acknowledgement of the King's return to health. On the left in official robes stand Lord Camden (President of the Privy Council) and Lord Thurlow (Lord Chancellor). Behind the throne is the Prime Minister, William Pitt the Younger. On the right in academic robes are the doctors who attended the King, notably Dr Francis Willis. Windsor Castle, where George III lived during his illness, may be seen in the background beyond Queen Charlotte. The inscriptions attached to the columns on the left refer to the protection of the King's political interests by Parliament during his illness, when a Regency Bill was first debated. West apparently displayed a transparency of this subject outside his own house in March 1789.

George IV in 1823. The decorations on the ceiling of the principal room were executed by a German artist called Haas in the rare medium of coloured marble dust (*marmortinto*) based on sketches dating from 1787–8 provided by West. Not all the sketches survive, but the central panel of 'Genius Calling forth Arts and Sciences' undoubtedly refers to the general theme honouring recent commercial and technological advances in Britain evident in agriculture, manufacturing, trades and scientific invention. The four surviving sketches and written descriptions of the overall programme refer to a diversity of subjects including astronomy, navigation, geography, chemistry and agriculture, as well as the arts. The figure of Britannia is an ubiquitous allegorical presence.

West's scheme for the Queen's Lodge recalls certain parts of the more audacious series of canvases completed in 1783 by James Barry for the Great Room of the Society for the Encouragement of Arts, Manufactures and Commerce in London. Although Barry's work had a certain relevance in its institutional setting, the location of West's scheme in a strictly private building adjacent to Windsor Castle denotes a shift away from the more public displays of royal status and splendour indulged in by the Stuarts. Furthermore, both Barry and West combine allegory with history and genre painting in a paradoxical way that is ultimately confusing and unconvincing. The syntax may have been right, but the vocabulary was wrong. In fact, both a new emphasis in royal patronage and the growing significance of history painting were together to play an important role in the development of the national school.

Political circumstances changed the pattern of royal patronage as absolutism retreated before the advent of a constitutional monarchy. The Restoration of 1660, the Glorious Revolution of 1688 and the arrival of the Hanoverians resulted in political changes that through legislation, including the Bill of Rights (1689) and the Act of Settlement (1701), brought about a more measured system of government allowing Parliament to exercise stricter

political and financial controls over the Crown. A conversation piece executed on a vast scale by George Knapton, *The Family of Frederick, Prince of Wales* (1751), alludes to these developments (fig. 6). Frederick, Prince of Wales, is shown posthumously in a portrait on the left indicating his widow, Augusta, Princess of Wales, who presides over their children; the heir, the future George III, is by the column left of centre. At the right edge below a statue of Britannia is a bas-relief symbolising the constitution and the Hanoverian succession. A pair of scales, on one side of which is the crown with sceptre and on the other the cap of liberty with staff, is prominent. In front of the scales is a brazier (symbol of constancy). Also visible are a sword, the Union flag in the form of a shield, a lion with the cap and staff of liberty, a branch of laurel and a mitre. Documents inscribed 'Magna Carta' and 'Act of Settlement' are also evident.

The court by this time had ceased to be the principal focus of patronage as it remained elsewhere in Europe, and under the Hanoverian dynasty monarchs became facilitators as opposed to instigators or arbiters of taste. It was no longer incumbent on the monarch to give a public lead. The approach was more guarded and dictated more by personal delectation, as opposed to any sense of official responsibility. Palaces designed for public displays of works of art were replaced by residences for private enjoyment. Such was the essence of Buckingham House, acquired by George III in 1761, and such was the purpose of George IV's redesigning of Windsor Castle. Still vested in the monarch and members of the royal family was the power to appoint artists to court positions such as Principal Painter or as specialists in the art of history, portrait, landscape or miniature painting. These positions were filled by recognised artists of great distinction – Ramsay, Reynolds, West, Cosway, Lawrence, Wilkie – but their duties, especially as regards the production of State Portraits, were not always easy. Most regarded such appointments as a mixed blessing and certainly not as their principal source of income. As John Brewer expresses it in *The Pleasures of the Imagination* (1997), 'The greatest value of royal patronage lay in its social cachet . . . In short, the British monarch acted as a private patron, rarely as a national one.' The monarch thus became *primus inter pares* and not the sole arbiter of taste during the eighteenth and nineteenth centuries, just when painting, music, theatre and literature were becoming formally recognised as expressions of national identity. The vacuum that this shift created was filled not just by figures drawn from a broader social spectrum with sharper entrepreneurial skills, but also by the establishment of new institutions enshrining a different set of priorities. In David Solkin's words, 'The fact that monarchs and ministries showed little or no interest in high culture may often have provoked complaints of neglect, yet official indifference may also have had certain beneficial side-effects, by allowing the art world to develop as a zone largely free of the partisan strife that was the chronic condition of political debate' (*Painting for Money*, 1992). The public role of royal patronage was replaced by the private interests of sovereigns that did not have the same direct impact on the cultural scene.

It was remarked by Horace Walpole in his *Anecdotes of Painting in England*

Figure 6 (opposite) George Knapton (1698–1778), *The Family of Frederick, Prince of Wales*. Oil on canvas. 350.6 × 462.3 cm. Signed and dated 1751. Royal Collection (Windsor Castle)

The composition is on an unusually large scale for what is in effect a conversation piece. Frederick, Prince of Wales, who died on 20th March 1751, is represented posthumously, dressed in robes of state, in a full-length portrait to the left of the centre with a view of Kew Palace beyond. He points to Augusta, Princess of Wales, who is dressed in a black veil and dominates the centre of the picture. The future George III sits on the steps to the left together with his brother Edward, Duke of York. The baby held by the Princess of Wales is Princess Caroline Matilda, who was born on 11th July 1751. The composition is influenced by Van Dyck's formal group of the Pembroke family at Wilton House. Knapton successfully combines the theme of the Hanoverian succession with insights into the upbringing of children.

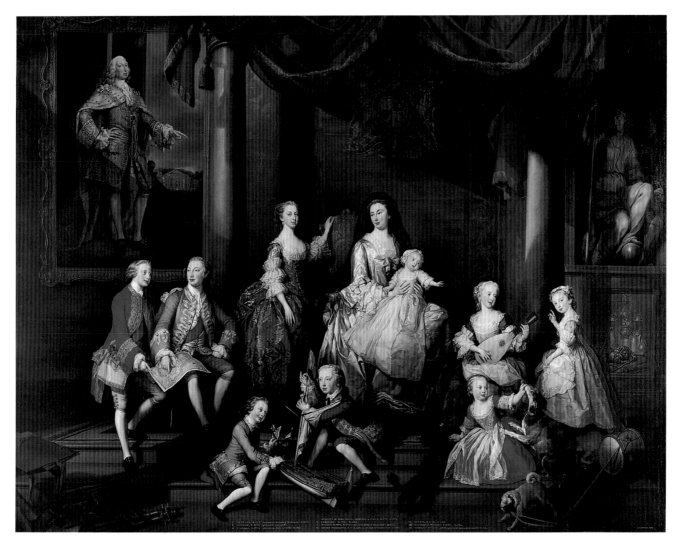

(1762–80) of the reign of George I at the beginning of the eighteenth century that 'We are now arrived at the period in which the arts were sunk to the lowest ebb in Britain.' While musicians, poets and philosophers were often considered to be the equal of their counterparts in Europe, Britain had still failed to produce any painters or sculptors of comparable status. The national school of painting was, therefore, born out of a state of inferiority, or even of accidie. Certainly, foreign artists played an important part in its development, if not in its formation. The influence of Van Dyck, Lely, Kneller and Watteau was felt by eighteenth-century British artists, but equally it was the desire to reject foreign ways – in name if not in example – that helped to define (as clearly as such an end is possible) Britishness in art. Just as what Sir Ellis Waterhouse referred to as 'inspissated insularity' was a handicap, so too it could be seen as an advantage in a process whereby indigenous characteristics could be more sharply defined when seen in reaction against a foreign background.

The paradox implicit in this situation is personified by the career of William Hogarth, the son-in-law of Sir James Thornhill. Hogarth determined to encourage contemporary British art by setting up informal academies for instruction and supporting institutions such as the Foundling Hospital, the

Society of Arts and the Society of Artists which were not dependent upon foreign models and benefited the painters themselves by providing an outlet for their work. A widely held objection to the eventual foundation of the Royal Academy of Arts in 1768, for instance, was not simply that its patron, George III, was royal, but that as an institution it was comparable with academies of long standing in France, Spain and Italy. The Royal Academy smacked of oligarchy and its members aimed to uphold a specific hierarchy of art with history painting at the apex. Hogarth chose not to adhere to any such thinking and he would have rejected the establishment of such a status quo. Indeed, his work was the product of a world in flux, a relentless critique of society and its ways. This involved a balancing act that is reflected in the wide range of his subject-matter, the elision between different types of painting he employed, and the fluency of his style. Hogarth also inveighed against those British aristocrats and collectors whose taste was formed, not to say fixed for ever, by making the Grand Tour. For Hogarth such visits to the continent were a form of betrayal, just as the formation of extensive collections of Old Master paintings was a form of blindness. One could, for instance, imagine Hogarth in this century applauding the world-wide success of those painters comprising the so-called School of London, or of the movement newly christened as Young British Artists.

The ambivalence of Hogarth's position was in some ways his main strength as an artist. During the early 1730s he was given an opportunity to engage directly in royal portraiture by depicting George II and Caroline of Ansbach with their children. Two preparatory sketches exist – one in the Royal Collection and one in the National Gallery of Ireland – showing alternative designs; namely, the group seen in a landscape setting and then in an interior. The exact circumstances of the commission are not known, but the project did not progress beyond these two oil sketches, possibly due to the intervention of William Kent. It is conceivable that Hogarth's concern for the development of the conversation piece might have been considered too informal in the royal context at this date. As a form of royal portraiture, the conversation piece seems only to have found full acceptance with the patronage of Johan Zoffany in the next reign.

Regardless of his failure to bring the portrait of George II and his family to fruition, Hogarth looked upon the accession of George III with a degree of hope. Two well-known prints made in connection with a catalogue for an exhibition of paintings organised by the Society of Artists in 1761 – the year after George III's accession – signify the polarities of Hogarth's position. The frontispiece (p. 128) illustrates the flourishing of the arts during the reign of George III, whereas the tailpiece lampoons those connoisseurs still preoccupied by the art of the Old Masters. Hogarth, however, died in 1764, four years before the foundation of the Royal Academy, an organisation he did his best to forestall. It is almost symbolic that in 1757 he had been appointed to the post of Serjeant-Painter, an outmoded court position soon to fall into desuetude, with a derisory annual payment.

The foundation of the Royal Academy in 1768 was a decisive factor in the growth of the national school of painting. The establishment of such an

institution came about in part as a result of the rivalry between the existing private teaching academies and exhibiting societies in London. However, the patronage of the new Royal Academy by George III, obtained through the intervention of Sir William Chambers, was an undeniable advantage in the negotiations. But from the start the new organisation was subject to incessant fierce criticism. For many radicals, such as John Wilkes, an academy brought into existence with the help of royal patronage smacked of absolutism and could be no more than a political faction. Similarly, it was felt that the various appointments required to be made to set up the Academy would encourage the creation of a coterie. This was indeed the case, as when George III insisted that Johan Zoffany be admitted as an academician, and when the coryphaic first president, Sir Joshua Reynolds, included so many of his friends (for example, Oliver Goldsmith, Samuel Johnson, James Boswell, Edward Gibbon and Guiseppe Baretti) amongst the Academy's officers. Actually, it could be argued that the inclusion of such luminaries reflects the array of talent available to Reynolds as opposed to an exercise in preferment. Some of the objections that were raised by contemporaries have been resurrected by recent historians. For John Brewer, 'The foundation of the Academy marked a triumph for an oligarchy among painters, a self-perpetuating body that decided what art should be exhibited as a public statement of good taste.' And for David Solkin, 'The Academy, to put it bluntly, had simply arrived too late', in so far as the attempt to lay down principles for a public art in the political climate of late eighteenth-century Britain could never be wholly disinterested and the Academy could therefore only have the opposite effect to the one desired.

Yet, to put too great an emphasis on the objections levelled against the Academy is to overlook its real significance. Firstly, the annual exhibitions provided a forum for the regular and much needed display of contemporary British art. Later, from the 1870s, this policy was extended to include loan exhibitions, principally of Old Master paintings and other forms of art. Two such – rather diverse – exhibitions devoted to British art were organised in 1934 and 1986. Secondly, it made provision for the teaching of students, in the process of which various presidents propounded their views on art in the form of lectures. Reynolds's fifteen *Discourses* delivered between 1769 and 1790 on the anniversary of the foundation are the most famous example of this tradition. As is well known, Reynolds argued in favour of an art with an intellectual basis of which history painting was the finest expression because it demanded high standards from the artist and was instructive for the viewer. The *Discourses*, in the words of Pat Rogers, remain 'the most practical, the most sensible and the best written discussions on the theory and practice of painting in the English language'. Those scholars who now argue that Reynolds was narrow-minded or doctrinaire fail to appreciate to what extent his own work disproves this. Reynolds himself strove to be a history painter, but without success. Instead, like Hogarth before him in *David Garrick as Richard III* (Liverpool, Walker Art Gallery), he significantly extended the range of portraiture so that in its descriptive powers and contextual emphasis it obtained

a status comparable with the grandest history painting. This development cannot be underestimated and it made possible the achievements of such a painter as Sir Thomas Lawrence.

The tendency to regard the foundation of the Royal Academy as a retrograde step overlooks its real significance. The opening paragraph of Reynolds's first *Discourse* (2nd January 1769) marking the official opening of the Academy reads, 'An Academy, in which the Polite Arts may be regularly cultivated, is at last opened among us by Royal Munificence. This must appear an event in the highest degree interesting, not only to the Artist, but to the whole nation.' This was therefore a defining moment in raising national consciousness comparable with the foundation of the Royal Academy of Music by George I in 1719; Samuel Johnson's *Dictionary of the English Language* (1755); the promotion of the cult of Shakespeare by David Garrick, culminating in the Jubilee celebrations of 1769; or those publishing ventures such as Macklin's Poets' Gallery (1788), Boydell's Shakespeare Gallery (1789) and Fuseli's Milton Gallery (1799), all of which were based on paintings and evoked the literary tradition of the country. The failure of the Academy to live up to its ideals (if that really is the case) should not be allowed to occlude its central purpose in the history of British culture. Correspondingly, the association of George III with the Academy was indicative of his declaration that 'Born and bred in this country, I glory in the name of Britain.' The royal family frequently visited the annual exhibitions held at Somerset House, which the King had made available to the Academy, and indeed one state of the famous print by P. A. Martini (after J. Ramberg) shows a view of Windsor Castle in the distance, implying a topographical correlation. George IV continued this close association by attending the annual dinners, in addition to the exhibitions; by lending one of the Raphael Cartoons for the students to copy; and by donating, among other items, casts of antique sculpture. On an institutional basis these links have been maintained into the present century. An important moment, for example, was the Winter Exhibition of 1946–7 ('The King's Pictures') when over five hundred paintings from the Royal Collection were put on view as part of a policy to boost public morale after the Second World War of 1939–45 (fig. 7).

That George III took his responsibilities seriously is demonstrated by his personal patronage of British artists. This began in a small way with the acquisition in 1765 of a painting by Nathaniel Dance ultimately based on a scene from Shakespeare's *Timon of Athens* (p. 70). The style and the subject-matter of this picture make it an early example of history painting as exemplified by the British School. A person who came to play a critical role in all of this is Sir Joshua Reynolds, but he was not liked by George III. Having been painted by Reynolds (1759) when still Prince of Wales, the King appeared reluctant to be portrayed by him again, although he eventually succumbed in 1779 when the President painted both the King and Queen Charlotte officially for the Royal Academy. The portraits are awkward and unsatisfactory, displaying an unease that characterised the royal couple's relationship with the artist. James Northcote explains this in a way that suggests Reynolds perhaps

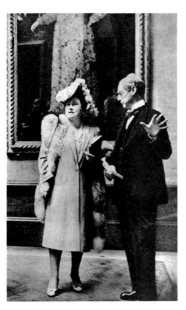

Figure 7 Queen Elizabeth The Queen Mother visiting the Royal Academy of Arts, 1946. Photograph (detail)

The photograph was published in *The Sphere* on 2nd November 1946 at the time of the exhibition 'The King's Pictures' held at the Royal Academy of Arts from 26th October 1946 until 16th March 1947. The exhibition comprised over five hundred paintings. 'Not only has the Exhibition the glory of containing many masterpieces of the greatest painters of Europe, but also the interest of showing the several main stages in the growth of this historic Collection, which has been built up by the contributions of a succession of sovereigns according to the tendencies of their personal tastes.' The Queen Mother is shown in the first gallery (Portraits before Van Dyck), accompanied by the President of the Royal Academy, Sir Alfred Munnings, at a special preview of the exhibition. The selection of pictures was made by Sir Gerald Kelly, Anthony Blunt, Ellis Waterhouse and Benedict Nicolson.

lacked a suitable sense of deference: 'The one was only King of a great nation; the other was the greatest painter in the world.' Eventually, 'The King and Queen could not endure the presence of him; he was poison to their sight... Do not suppose he was ignorant of the value of Royal favour. No – Reynolds had a thorough knowledge of the world. He would gladly have possessed it but the price would have cost him too much.' Reynolds for his part, although knighted in 1769, was finally appointed Principal Painter in succession to Allan Ramsay in 1784 – eight years before his death, when his powers were failing. He seems to have regarded this almost as an insult, memorably declaring in a letter (24th September 1784) to the Duke of Rutland, 'The place which I have the honour of holding, of the King's principal painter, is a place of not so much profit, and of near equal dignity with His Majesty's rat catcher. The salary is £38 per annum, and for every whole length I am to be paid £50, instead of £200 which I have from everybody else.' As a portrait painter, the King and Queen infinitely preferred the more relaxed and open-minded Gainsborough. The differences between Reynolds and George III, which were by no means limited to matters of status, undermine any suggestions of factionalism. In the same way, their support for Thomas Gainsborough, whose relationship with the Academy was stormy (he eventually broke off all contact in 1784), indicates that the court and the Academy could hold different viewpoints.

George III found the American painter, Benjamin West – who arrived in Britain in 1763 and was appointed Historical Painter in 1772, succeeding Reynolds as second President of the Royal Academy in 1792 – a much more sympathetic figure. In spite of tensions that arose during the struggle over the American colonies, West continued to work assiduously for the King. His output was prodigious, varying from history paintings and religious compositions to portraits and landscapes. West's facility (much criticised in his day and still not wholeheartedly appreciated) for devising dramatic narrative compositions from erudite subject-matter in a refined neo-classical style that on occasions veered towards romanticism, was timely. The idealism of George III's political and moral aspirations found a convincing outlet in West's mental agility and manual dexterity with the brush. As regards history painting, two series are of particular interest in the development of the British School. The first was the sequence of pictures painted between 1769 and 1773 decorating the Warm Room on the ground floor of Buckingham House. The piecemeal commissioning and eventual installation of these pictures in a single room were highly significant. The King himself was closely involved with the selection of subjects as the project unfolded, apparently even reading aloud relevant passages from the principal source (Livy's *History of Rome*) to the artist. At either end of the room were the largest pictures: *The Departure of Regulus* (p. 72) and *The Oath of Hannibal*, illustrating incidents in the Punic Wars. There were also two much smaller overdoors of classical subjects, but the main wall was adorned by three pictures: *The Death of Epaminondas* and *The Death of Chevalier Bayard* on either side of the fireplace, with *The Death of Wolfe* over the mantelpiece. The scenes illustrate the themes of heroism, chivalry and magnanimity through the course

of history extending from antiquity through the Middle Ages (or, more correctly, the Renaissance) to the eighteenth century itself. The surprise was the inclusion of the near contemporary incident of the death of Wolfe in 1759 on the Heights of Abraham above Quebec. The choice of this last subject was approved by the King, who had seen the prime version of *The Death of Wolfe* painted in 1770 for Lord Grosvenor. West duly obliged George III by painting a replica. The importance of West's treatment of Wolfe's death is that it supplemented history painting with other visual traditions – namely, topical illustration and portraiture. This mixture represented a great advance in history painting, which then progressed rapidly. As Reynolds is reported to have said correctly, after some initial misgivings, 'I foresee that this picture will not only become one of the most popular, but occasion a revolution in the art.'

The second series was for the Audience Room in Windsor Castle, for which eight canvases were painted between 1786 and 1789. The subject seems to have been selected by George III, who, 'recollecting that Windsor Castle had in its present form, been erected by Edward the Third, said, that he thought the achievements of his splendid reign were well calculated for pictures, and would prove very suitable ornaments to the halls and chambers of that venerable edifice'. Reference is made in two of the paintings to the foundation of the Order of the Garter, but the other scenes pertain to Edward III's campaigns during the Hundred Years War against the French. West used literary sources such as Elias Ashmole's *Institution, Laws and Ceremonies of the Most Noble Order of the Garter* (1672) and David Hume's *History of England* (1754–62), as well as the researches of antiquarian scholars such as Joseph Strutt and Francis Grose for the armour and weapons. Again, the themes are heroism, chivalry and magnanimity, but this time set firmly in the context of the Middle Ages. The result is one of the first decorative schemes illustrating incidents from early British history to have survived.

Royal interest in British painting was maintained by George IV, but in a more varied way. During the early 1790s while still in his 20s he commissioned seventeen out of the eighteen paintings by George Stubbs that are in the collection (see p. 64). Unlike George III, he had the capacity to enjoy the work of both Gainsborough and Reynolds, commissioning major portraits of himself, his relatives and his friends from both artists. It is due to his perspicacity that such diverse pictures as the oval of *Henry, Duke of Cumberland with the Duchess of Cumberland and Lady Elizabeth Luttrell* and *Diana and Actaeon* (p. 66) – both sold after Gainsborough's death – were obtained. Similarly, Reynolds's niece, Lady Thomond, knowing George IV's appreciation of the artist's work, presented him with the late *Self Portrait* in 1812 (see p. 60) and *Cymon and Iphigenia* in 1814, and at Lady Thomond's sale in 1821 George IV acquired *The Death of Dido* (p. 58). Thus, two of Reynolds's most important narrative paintings came into royal possession and bear out Gainsborough's claim that 'in his opinion Sir Joshua's pictures in their most decayed state were better than those of any other artist when in their best'.

George IV's interest in history painting, however, was not as consistent as

his father's. The most voluble proponent of history painting of the younger generation was the unfortunate Benjamin Robert Haydon. His ambitious ideas, fuelled artistically by his admiration for the Elgin Marbles and the Raphael Cartoons and emotionally by his veneration for Napoleon, were not matched by his skills as a painter. In the final analysis he was unable to devise convincing compositions crowded with figures and his handling of paint was technically unsound so that his passionate commitment was rarely successfully translated onto the finished canvas. The range of his undertakings was as formidable as West's; his projects extend from obscure heroes of the classical past through a variety of biblical subjects to topics inspired by ancient and contemporary British history, as well as literature. Yet there was a limited number of patrons for work of this kind, often conceived on an epic scale. Added to this was Haydon's mercurial temperament, governed by his determination to succeed on the basis of his almost uncontrollable self-confidence. The success of West and the advent of J. M. W. Turner show that Haydon's cause was justified, but he lost support to the extent that depression and persecution mania led to his suicide with a razor and pistol on 22nd June 1846. Haydon's *Journal* is a fascinating source for British art and literature in the early nineteenth century, but on a human level the painter's despair is harrowing.

Haydon sought royal patronage for his work and thus by extension support from the same quarter for the British School. However, George IV's interest in narrative painting was far more varied than that of the single-minded Haydon. The only work by the artist that he bought was *The Mock Election* of 1827–8 (p. 88), which is set in the King's Bench Prison for debtors where Haydon himself was incarcerated from time to time. It is, in fact, based on a humorous incident that he witnessed there. The painting is really an exercise in genre and its satirical social overtones are Hogarthian, although on a much grander scale. The picture, which shows a cross-section of society, has to be seen in the context of the political agitation for the Reform Act of 1832 and the antiquated laws for imprisonment for debt. Haydon's exhilaration following the purchase of this picture by George IV in 1820 is detailed in his *Journal*, but the King declined to acquire its pendant, *Chairing the Member* (now in the Tate Gallery). A similar fate befell *Punch, or May Day* (also in the Tate Gallery), which Haydon painted as an alternative to *Chairing the Member*, hoping that the King would prefer it. The composition has been described as 'a Hogarthian compendium of London characters on a festive day', but it failed to please the King. By an artist who declared, 'What are ... small pictures to me? – disgusting. I am adapted to great national work, to illustrate a national triumph or a moral principle', perhaps one painting was enough. But Haydon in the midst of his profound depression sadly but accurately detected a sea change in the development of British art. The entry in his *Journal* for 2nd October 1844 reads, 'The solitary grandeur of historical painting is gone. There was something grand, something poetical, something mysterious in pacing your quiet Painting room after midnight, with a great work lifted up on a gigantic easel.'

George IV was more supportive of Haydon's friend, the Scottish artist, Sir

THE QUEST FOR ALBION

David Wilkie. The first two acquisitions, *Blind-Man's-Bluff* (1812) and *The Penny Wedding* (1818), were outstanding examples of his genre paintings, in a style influenced by Dutch and Flemish art. Later, Wilkie's art underwent a transformation following a protracted visit of three years to the continent (1825–8) prompted in part by illness. While travelling Wilkie absorbed the art of Titian, Rubens, Velázquez and Murillo. The greater freedom of his ensuing style enabled Wilkie to undertake history paintings in the manner of Eugène Delacroix, and George IV acquired four such pictures in 1829–30. Of these, *The Defence of Saragossa* dating from 1828 was the most dramatic and illustrates a scene from the Peninsular War (1808–14) – a subject also painted later by Haydon (1836–42).

George IV's appreciation of Wilkie's depictions of incidents from the Peninsular War is indicative of one aspect of his interest in history painting. This admiration for feats of arms and military prowess knew no bounds. It even extended to a deep fascination with the personality and professional skills of the Emperor Napoleon, whose success in ruling France threatened the safety of Europe. The overthrow of Napoleon was an outcome that George IV savoured to the extent that in his fantasies, regardless of his admiration for the Duke of Wellington, he believed that he himself had played a major role in the military campaigns and diplomatic negotiations. The commissioning from Sir Thomas Lawrence of the portraits for the Waterloo Chamber in Windsor Castle is the artistic manifestation of this particular thought-process. This series of portraits (1814–20) of those statesmen, soldiers and diplomats who were responsible for the overthrow of Napoleon and for redrawing the map of Europe amounted to a pantheon in which portraiture, in West's words, rose 'to the dignity of history'. James Northcote, a pupil of Reynolds, perceptively remarked that 'there has been nothing like it except in the instances of Rubens and Vandyck … It wd. raise the credit of English art abroad and make it more respected at Home.'

Yet, George IV's sense of patriotism was broadly based, judged by the paintings he had hung in two of the main rooms in St James's Palace. The Ante-Room (or Entrée Room) was dominated by two enormous canvases of sea-battles on either side of a portrait of George III by Lawrence. On one side was P. J. de Loutherbourg's *The Battle of First of June 1794*, balanced on the other by J. M. W. Turner's *The Battle of Trafalgar* – the largest picture the artist ever painted. The criticism that Turner's composition elicited, mainly concerning nautical details, caused George IV to give both pictures to the Naval Hospital at Greenwich, from whence they eventually passed to the National Maritime Museum. Turner felt that this was a royal rebuff. Next to the Ante-Room is the Throne Room where Lawrence's State Portrait of George IV was positioned as an overmantel with two military scenes by George Jones on either side: the *Battle of Vittoria* and the *Battle of Waterloo*, both occasions on which the Duke of Wellington was in command. This arrangement remains in place.

At the beginning of Queen Victoria's reign Haydon wrote retrospectively in his *Journal* (11th August 1841): 'English Art never stood higher than at the end of the War [Napoleonic Wars]. Foreigners were astonished at our condition, & they might well be. The reason was, blockading kept the rich from running over the

continent; our energies were compressed & devoted to ourselves, & we flourished accordingly. Wilkie was in his zenith, so was Lawrence, so was Flaxman, so were our Water Colour Painters, & so was I, for my Solomon was an English Triumph, & Landseer was beginning to bud.' Even so, by the time Haydon was composing this entry for his *Journal* the hierarchies of painting had changed. Added to this, Queen Victoria's taste differed notably from George IV's. For the Queen, history painting was more a matter of recall than an act of imagination. As a result, history painting amounted to ceremonial pictures marking the chief events of her long reign, as well as depictions of the military actions and diplomatic ventures associated with Empire. British painters – Wilkie, Sir George Hayter, Sir Francis Grant, C. R. Leslie, W. P. Frith, George Thomas – were on hand early in the reign for ceremonial pictures and portrait commissions; but later, on a general basis, Queen Victoria resorted more regularly to foreign painters such as F. X. Winterhalter, Laurits Tuxen, Rudolf Swoboda and Heinrich von Angeli. For military and imperial subjects the Queen's preferences were for Lady Butler and R. Caton Woodville (*The Guards at Tel-el-Kebir*, *'Too Late': The Last March of General Sir Herbert Stewart*, *The Memorial Service for General Gordon*). Queen Victoria's expectations were quite clear when it came to this type of painting, as evidenced by the example of Lady Butler. Her picture of a scene from the Crimean War, *The Roll Call* (p. 114), which was commissioned by the industrialist Charles Galloway but ceded (somewhat reluctantly by him to the Queen and in competition with the Prince of Wales) in 1874 after its popular success at the Royal Academy, could be seen as a pessimistic view of the engagement. Later, when Queen Victoria commissioned her own picture from Lady Butler, the famous defence of Rorke's Drift (1879) in which eleven Victoria Crosses were won was the preferred subject.

For the most part Queen Victoria favoured pictorial accuracy in British painters. W. P. Frith's *Ramsgate Sands* (p. 104) falls undeniably into this category, partly because the Queen knew Ramsgate well and partly because it depicts a cross-section of society, but it is possible that the artist's daring viewpoint was overlooked. Similarly, when Queen Victoria visited France she felt drawn towards paintings by artists of the Second Empire such as Paul Delaroche and Ernest Meissonier, as opposed to the more avant-garde painters emerging during the 1860s and 1870s. The same lack of adventure is apparent in the Queen's approach to British painting. George V famously recounted to Kenneth Clark that 'Turner was *mad*. My grandmother always said so', but even more approachable works by Pre-Raphaelite artists, such as *Christ in the Carpenter's Shop* by Sir John Everett Millais and *The Finding of the Saviour in the Temple* by William Holman Hunt, were inspected but inexplicably not acquired. The one artist she did support consistently throughout her reign was Sir Edwin Landseer (a one-time pupil of Haydon), whose prevarications, sensitivities, nervous disorders and intermittent alcoholism she tolerated with the greatest patience. This was not simply because of a shared love of the Highlands, but because in many respects Landseer made a greater contribution to royal iconography than any artist since Van Dyck. The early *Windsor Castle in Modern*

Times (1840–3) is an essay in the conversation piece but, unfortunately, the equestrian portrait and the major narrative composition *Royal Sports on Hill and Loch* (see preparatory sketch, p. 98) fell foul of Landseer's lapses and loss of confidence. The equestrian portrait was begun boldly and challengingly in 1838, but brought to an uncertain conclusion as late as 1872. A similar fate befell *Royal Sports on Hill and Loch*, which was initiated in 1850–1 but took twenty years to reach its unhappy end. Landseer himself was disappointed with the final picture, the surface of which he overworked in desperation. Ultimately, its condition deteriorated to the point that it had to be destroyed. The final composition is known now only through the engraving by W. H. Simmons dating from 1874.

Landseer was granted a privileged position by Queen Victoria. His good looks, warm personality and humour ensured his success at court and socially in a wider sphere. He was the most extensively published artist of his day in Britain through engravings and his work was well received in France. He received over two hundred commissions from Queen Victoria alone, including several pictures of a distinctly private nature – portraits of royal children, relations (p. 96) and pets, the Queen and Prince Albert in fancy dress for a ball and, finally, the Queen alone in her widowhood at Osborne House. Such pictures as *The Sanctuary* (1841), *Eos* (1842) and even *The Drive* of 1847 (now much damaged) are amongst Landseer's finest works, but there are no historical paintings by him in the Collection. Landseer was a talented, but ultimately unimaginative, painter who found the depiction of narrative particularly difficult. He was, none the less, a superb painter of animals, even though his proclivity for anthropomorphism does not appeal much today. In the final analysis, Sir Michael Levey's description of Landseer as an artist who 'had commonplace ideas of composition and a French polisher's idea of finish' seems somewhat harsh.

Queen Victoria's interest in the visual arts was nurtured by Prince Albert, whom she married in 1841. He possessed the mind and energies of a polymath, added to which were his considerable organisational skills. During the course of their marriage (the Prince died in 1861), the Queen acquired Osborne House in 1843 and Balmoral Castle in 1847, both of which became focuses for royal patronage. But Prince Albert had a genuine interest and wide knowledge of art, as he did of music and science. Furthermore, he enjoyed the company of artists and connoisseurs such as Sir Charles Eastlake and Ludwig Grüner on an Anglo–German axis. The paintings (and miniatures) in the Royal Collection were duly scrutinised and assessed. Acquisitions were plentiful, although profligate expenditure in the manner of George IV was always kept in check. Underpinning Prince Albert's personal taste was a pronounced sense of historicism, which was not unrelated to his interest in contemporary British painting. Only a few collectors by the mid-nineteenth century recognised the significance of early Italian, Netherlandish or German painting; the Prince not only responded to the aesthetic qualities of such works, but also saw that there were few examples in the Royal Collection. As a result, works by Italian artists of the calibre of Duccio, Bernardo Daddi and Gentile de Fabriano were added as individual items, while in

Figure 8 (opposite, above) Samuel Dumkinfeld Swarbreck (active 1839–1881), *View of the Prince Consort's Swiss Cottage in the Grounds of Buckingham Palace 1847*. Watercolour. 286 × 413 mm. Signed, inscribed and dated on the original mount. Royal Collection (Windsor Castle, Print Room)

The Garden Pavilion, built in the grounds of Buckingham Palace by Queen Victoria and Prince Albert in 1842, was also known as Swiss Cottage. The structure is seen left of centre. Buckingham Palace garden is viewed from a high vantage point from Lower Grosvenor Road. John Nash's west façade to the Palace, which overlooks the garden, is clearly discernible over the rooftops in the right foreground. The Garden Pavilion fell into a state of dilapidation and was pulled down in 1928.

Figure 9 (opposite, below) Ludwig Grüner (1801–1882), *The Interior of the Garden Pavilion, Buckingham Palace*. Chromolithograph from *The Decoration of the Garden Pavilion in the Grounds of Buckingham Palace*, London 1846

The publication of 1846, overseen by Ludwig Grüner, is the only record of the completed interior of the Garden Pavilion. The building was dominated by a central octagon, the lunettes of which were decorated with subjects taken from John Milton's *Comus*. Of the two smaller rooms, one was decorated with subjects from the works of Sir Walter Scott and the other in the Pompeian style. The significance of the building lies in the use made by the eight artists involved of the fresco technique. Grüner lived in England from 1841 until 1856 and advised Prince Albert on artistic matters. He eventually became Director of the Cabinet of Engravings at Dresden.

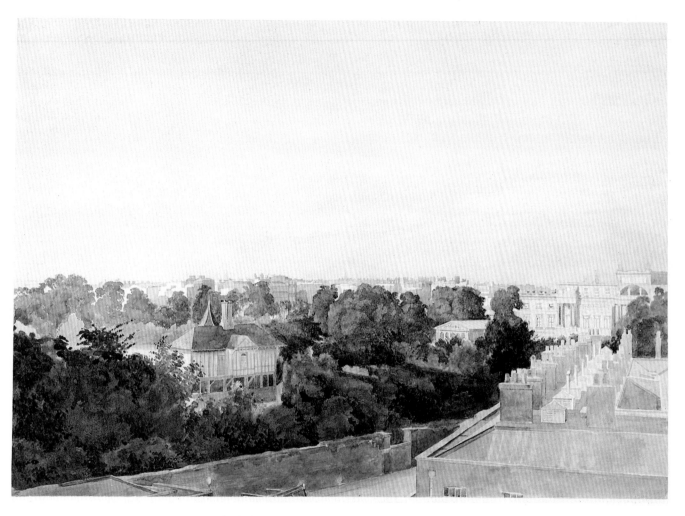

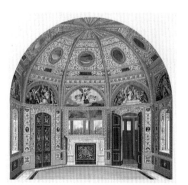

1848 the acquisition of the collection of primitives formed by Prince Ludwig Kraft Ernst Oettingen Wallerstein came about because the owner defaulted following a financial loan from Prince Albert. The cream of this collection was given in 1865 by Queen Victoria to the National Gallery in memory of Prince Albert.

Interest in early painting was allied to a fascination with techniques, which led Prince Albert to play a leading role in the revival of fresco painting in Britain. In this aspect he was undoubtedly influenced by the achievements of the German Nazarene artists, whose work he must have known from before his marriage. As a personal initiative in this cause Queen Victoria and Prince Albert in 1842 built the Garden Pavilion in the grounds of Buckingham Palace (fig. 8). Designed by Edward Blore, its interior comprised a central octagonal space with lunettes and two smaller outer rooms. The main decorations in the lunettes of the octagon were illustrations of scenes from Milton's *Comus* (fig. 9). The artists – all leading Royal Academicians – were Sir Charles Eastlake, William Etty (replaced by William Dyce), Landseer, C. R. Leslie, Daniel Maclise, Sir William Ross, Clarkson Stanfield and Thomas Uwins, who worked under the direction of Grüner. Milton's poem combined a patriotic theme with classical sources in the same way as the Garden Pavilion encouraged British painters to use fresco in a setting ultimately inspired by Raphael's Vatican *Logge*. The Garden Pavilion was a worthy experiment but the artists, not

surprisingly, encountered technical and personal difficulties. The building gradually fell into disrepair and was finally pulled down in 1928.

Many of the paintings acquired by Queen Victoria and Prince Albert were of personal significance in their choice of subject, often marking special anniversaries, but there was on such occasions a tendency to employ second-rate painters. Yet, some outstanding purchases were made in this category: John Martin's *The Eve of the Deluge* in 1841, Daniel Maclise's *A Scene from 'Undine'* in 1843 (p. 102), Frederic Leighton's enormous *Cimabue's Madonna carried in Procession* in 1855 (now on loan to the National Gallery) and William Dyce's *The Virgin and Child* in 1845 (p. 101). These pictures alone are representative of several aspects of Victorian painting at its best but, if one should be chosen as representative of the intertwined taste of Queen Victoria and Prince Albert, it is surely the work by Leighton, whose reputation while still a young man was established overnight.

Prince Albert's political position was never easy, but his enthusiasm, abilities and knowledge in the field of the arts eventually overcame rancour. He was an admitted interventionist (his speeches at Royal Academy dinners were rigorously argued) and there were those, like the picayune cartoonists in *Punch*, who regarded him as an interfering foreigner and those who welcomed his support, such as the editor of *The Art-Union* (later *The Art Journal*). Like George III, he became an ardent spokesman for his adopted country. As his Private Secretary, Sir George Anson, remarked in July 1841, 'Arts and science look up to him as their especial patron, and they find this encouragement supported by a full knowledge of the details of every subject.' Quite apart from any guiding influence he had on Queen Victoria, Prince Albert's greatest asset was his public-spiritedness. Appointed President of the Fine Arts Commission by Sir Robert Peel in 1841 with Eastlake as Secretary, he became involved with several public projects of considerable import (fig. 10). The first of the two most extensive of these projects was the decoration of the new Palace of Westminster rebuilt from 1840 by Sir Charles Barry and A. W. N. Pugin following the fire of 1834. As with the Garden Pavilion at Buckingham Palace, Prince Albert revealed his knowledge of contemporary German culture, but aimed to put it to Britain's advantage. The selection of mythic, literary and historical subjects executed in the fresco medium seemed to be an appropriate statement for a building of such national significance and focus. The size of the murals and the unfamiliarity of the medium encouraged a great deal of discussion following the competition held in 1843. The actual decorations were not begun until 1850. As Richard Ormond has written (*Early Victorian Portraits*), 'If, in the final analysis, the attempt to create a form of high art, in keeping with the spirit of the new Victorian Age, was, almost inevitably, a failure, and no more than an interesting incident in the history of English art, it was the most notable example of state patronage in England since the Middle Ages.' Many of the artists chosen to undertake the decorations – Eastlake, C. W. Cope, Maclise, E. M. Ward, Dyce and J. C. Horsley among them – were known to Prince Albert and were, either already or about to be, represented in the Royal Collection. In

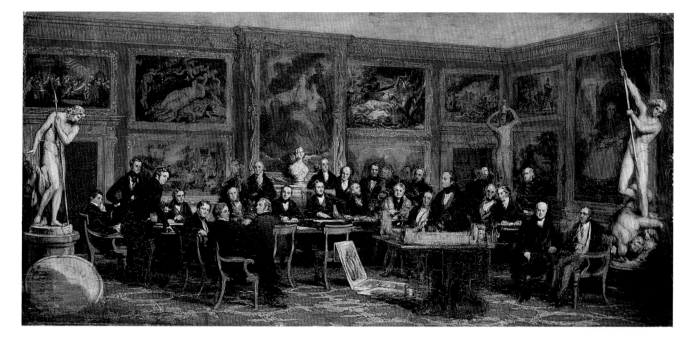

Figure 10 John Partridge (1790–1872), *The Fine Arts Commissioners, 1846*. Oil on paper laid on canvas. 47.6 × 86 cm. London, National Portrait Gallery

An oil sketch for the large picture undertaken at the prompting of the Prince Consort and completed *c.*1853. The finished painting (also in the National Portrait Gallery) is now ruined as a result of bitumen. The Commission was appointed in November 1841 to oversee the rebuilding of the Palace of Westminster with a view to 'promoting and encouraging the Fine Arts' in England. Partridge depicts twenty-five figures including Prince Albert (seated in the middle below the sculpted bust of Queen Victoria) and the Prime Minister, Sir Robert Peel (seated in the left foreground). The Secretary, Sir Charles Eastlake, later Director of the National Gallery, sits with pen poised next to the Prince Consort. There are several slight differences between the oil sketch and the finished picture. The setting is Gwydir House (Whitehall), hung 'with an imaginary collection of the works of our principal deceased Artists'.

the meantime (1847) Dyce successfully completed the large mural over the stairs at Osborne House. This throwback to an earlier tradition of painting was suitably entitled *Neptune Resigning his Empire of the Seas to Britannia*.

The second project with which Prince Albert became engaged was the Great Exhibition of 1851 held in Hyde Park and housed in the Crystal Palace. Together with Henry Cole, the Prince undertook the organisation, including solving all the practical difficulties. The scale was phenomenal, not only of the Crystal Palace itself, but of the whole enterprise. The exhibits (over 100,000) were divided into four broad categories: raw materials, machinery, manufactured goods and works of art. The purpose, according to Prince Albert, was to stress 'England's mission … to put herself at the head of the diffusion of civilisation and the attainment of liberty'. Once open, the Great Exhibition proved to be a universal success with its mixture of the didactic and the idealistic, and it certainly achieved popular appeal (over six million visitors in five and a half months).

Prince Albert's energies and enthusiasm took him into other areas concerning the arts such as the establishment of Schools of Design both in London and in other cities, as well as into supporting (and contributing to) the 'Art Treasures' exhibition of 1857 held in Manchester. This was the greatest art exhibition ever mounted (for example, there were approximately 1,100 Old Masters, 700 contemporary works, 386 British portraits and 1,000 watercolours alone, quite apart from the decorative arts) and it was comparable in its range and visual impact to visiting nine separate specialist museums. Nearly a million visitors (including many foreigners) saw the 'Art Treasures' exhibition, which was open for four months.

However, perhaps the greatest testimony to Prince Albert's optimism grew directly out of the Great Exhibition. It was decided that the profits could be used to acquire a 12-hectare (30-acre) site at South Kensington where – apart from several teaching institutions, buildings for societies and the Royal Albert

Hall – the National History Museum, the Science Museum and the South Kensington Museum (later known as the Victoria and Albert Museum) were also planned and soon to be constructed. What was envisaged was in effect an 'Albertopolis' presided over today by the Albert Memorial in Kensington Gardens. There can be no doubt that Queen Victoria and Prince Albert, in the words of Sir Oliver Millar, 'during the 1840's and 1850's, had generated, and been involved in, more artistic activity in their private life, and in the spheres outside it in which the Prince was so active, than has been created at any time since his death. Theirs is the last moderately heroic chapter in the history of royal patronage and taste in this country.' However, what is most impressive about Prince Albert was his ability to see beyond the confines of the Royal Collection, to view it in a national context, and to ally it with other related causes. This was a significant development.

If the eighteenth century witnessed the growth of national identity, the nineteenth century presided over the advance of nationalism. Yet, even within such a historical framework the enshrining of a national school of painting remained elusive. The existence of the Royal Academy and the opportunities for exhibitions provided by such organisations as the British Institution (founded in 1805 and with which George IV was closely involved) and the Burlington Fine Arts Club (founded in 1856) continued to encourage artists, but formal recognition of a national school was slow in coming. The establishment of the National Gallery in London in 1824 was a belated acceptance by a European power of its need to trumpet its cultural patrimony, but this was consciously and predominantly done by way of Old Masters as opposed to examples of the British School. Only the foundation of the National Portrait Gallery in 1856 potentially provided a focus for the illustration of British history through art. A further initiative for a permanent display of British art was taken in 1897, two years before his death, by Sir Henry Tate, the sugar magnate, whose collection and munificence gave a more positive lead in the creation of a national collection of British art. Tate's offer was grudgingly accepted by the government and difficulties were encountered over the choice of an appropriate site. Even so, the Tate Gallery at Millbank was initially a subsidiary of the National Gallery, becoming semi-independent in 1917 with its own board of trustees, acquiring its own purchasing grant in 1946 and becoming totally independent from Trafalgar Square only in 1954. Furthermore, the Tate Gallery has always suffered from an identity crisis in the division dating from 1917 between British art and modern foreign art which will only be resolved by the transformation of the Bankside building for 'modern' art while 'British' art will remain at Millbank. According to the Director, Nicholas Serota (The Times, 19th July 1997), this will allow the Tate Gallery 'to nurture and further stimulate appreciation of both historic and contemporary British artists'. In short, he continues, 'The Tate Gallery of British Art will offer a superb opportunity to set the record straight on our national achievement in the visual arts.'

The confusion that has reigned in the Tate Gallery is evident elsewhere in our national collections. The acquisition of British paintings by the National

Gallery has not always been consistent. There were distinguished pictures in the John Julius Angerstein collection to which William IV, George Salting and Henry Vaughan, amongst a few others, added sporadically, but once in the gallery their role alongside the foreign schools has always been difficult to define. This situation has had the effect of dissipating the impact of the British pictures in the National Gallery, sustaining the feeling of inferiority of British painting in the context of European art as a whole. The Robert Vernon Gift (1847) and the Turner Bequest (1856) further exacerbated this situation as pictures were moved between the National Gallery, South Kensington and Millbank. Only in very recent times has the relationship between the National Gallery and the Tate Gallery begun to be properly defined.

The problem at the Victoria and Albert Museum has again been one of definition. At its inception the emphasis was on British paintings, as evidenced by the John Sheepshanks Gift of 1857, the Townshend Bequest of 1869, the Forster Bequest of 1876 and the Jones Bequest of 1882. There was in these benefactions a preponderance of British works and the paintings collected by Sheepshanks were regarded as the nucleus of an incipient National Gallery of British Art. This ambition was fostered by special displays and exhibitions. But quite soon in the Museum's history its purpose was redefined to focus on the decorative arts not just on a continental basis but globally. The vast quantities of nineteenth-century British art gradually became subsumed as the Museum developed and its association with a National Gallery of British Art was lost. This ambition was thus almost unconsciously transferred to Millbank.

The plight of the British paintings in the Royal Collection is a mirror image of this situation. The interests of the most distinguished and active of royal collectors – Charles I, George III, George IV and Queen Victoria – were diverse and the representation of British art is in effect patchy. There are, none the less, unrivalled groups of works by Holbein, Van Dyck, Lely, Kneller, Ramsay, West, Zoffany, Reynolds, Gainsborough, Stubbs, Marshall, Hoppner, Beechey, Lawrence, Wilkie and Landseer. But, on the other hand, there are gaps, as might be expected in a collection that has been formed in a haphazard way in response to the personal taste of monarchs seeking to decorate the walls of royal residences as opposed to those of a national gallery. Certain types of British paintings abound – portraiture, equestrian, military, marine – but there are few landscapes. Conversely, there are surprising gaps: no works by Romney, Raeburn, Turner, Morland, Constable or the Pre-Raphaelites, and nothing of true significance after 1900. If chance and circumstance have been the strength of the Royal Collection, the failure to acknowledge twentieth-century British painting, particularly the contribution made during the last few decades, is regrettable. It is as though the British paintings in the Royal Collection are trapped within the historical dimension. By contrast, national institutions, although born in a spirit of historicism, have been able to escape from this dilemma by virtue of having to seek to be comprehensive. Yet, this essential difference between the Royal Collection and the national collections does not reduce the significance of its holdings.

A dramatic example of this is the fact that of the two touchstones for the development of the British School one is in the Royal Collection. While the Elgin Marbles reached Britain in the early nineteenth century, the Raphael Cartoons were acquired by Charles I in 1623 when he was still Prince of Wales. Ostensibly, these seven surviving cartoons, which were made by Raphael in connection with the tapestries commissioned by Pope Leo X in 1515 for the Sistine Chapel in Rome, were acquired for use at the Mortlake tapestry works established by James I in 1619. By the beginning of the eighteenth century, however, the Cartoons had ceased to be regarded as utilitarian objects and had become works of art in their own right. Thus, the Cartoons were incorporated in The King's Gallery in that part of Hampton Court Palace designed by Sir Christopher Wren for William III and Mary II. Sets of engravings and copies by influential artists such as Thornhill increased their reputation to the extent that major theorists such as Jonathan Richardson the Elder in 1722 openly declared that Raphael's finest works were not in Italy but to be found in London and accordingly that the Cartoons themselves constituted an academy of art. The challenge was to create a national school of painting that respected possession of the Cartoons and gave the artists of this country an advantage over all others. Richardson made Raphael an honorary British citizen; even Hogarth paid attention to them, Reynolds (encouraged by Johnson) expatiated on them, Garrick created a more expansive style of acting because of them and William Hazlitt waxed lyrical about them ('There is a Spirit at work in the divine creation before us').

By the mid-eighteenth century the Raphael Cartoons were hanging in Buckingham House, a fact that was not lost on the radical politician John Wilkes, Member of Parliament for Middlesex. Contrasting William III's enlightened display of the Cartoons at Hampton Court Palace, to which the public were admitted, Wilkes took exception to such famed works of art 'perishing in a late baronet's smoky house at the end of a great smoky town ... Can there be, Sir, a greater mortification to any English gentleman of taste, than to be thus deprived of feasting his delighted view with what he most desired, and had always considered as the pride of our island, as an invaluable national treasure, as a common blessing, not a private property.' George III ignored this splendid piece of invective and moved the Cartoons to Windsor Castle before subsequently returning them to Hampton Court Palace, where their condition gradually deteriorated. On the foundation of the National Gallery several artists, notably Haydon, advocated hanging both the Raphael Cartoons and the *Triumphs of Caesar* by Andrea Mantegna (also in the Royal Collection at Hampton Court Palace) in the National Gallery, but this was not to be. Eventually, partly at the instigation of Prince Albert, the Cartoons were in 1865 placed on loan in the Victoria and Albert Museum, as illustrative of the history of the arts of design.

On these counts, and also by a continuing policy of accessibility through displays in state rooms and loans to exhibitions, it can be seen that over several centuries the Royal Collection has played a fundamental part in the establishment of a British school of painting. The part cannot be described as a

proselytising one, but the accumulation of British pictures by monarchs began well before the leading national institutions were founded and there is some justification for saying that monarchy was instrumental in creating the taste for British painting, as well as for providing the basis (if not the momentum) for the establishment of a national school. Monarchy's role in the Quest for Albion has therefore been a critical and, in many respects, an exemplary one.

Christopher Lloyd
Surveyor of The Queen's Pictures

Further reading

Winslow Ames, *Prince Albert and Victorian Taste*, London 1967

John Barrell, *The Political Theory of Painting from Reynolds to Hazlitt*, New Haven and London 1986

T. S. R. Boase, *English Art 1800–1870*, Oxford 1959

John Brewer, *The Pleasures of the Imagination. English Culture in the Eighteenth Century*, London 1997

Morris R. Brownell, *Samuel Johnson's Attitude to the Arts*, Oxford 1989

Linda Colley, *Britons. Forging the Nation 1707–1837*, New Haven and London 1992

Edward Croft-Murray, *Decorative Painting in England 1537–1837*. Vol. 1 – *Early Tudor to Sir James Thornhill*, London 1962, vol. 2 – *The Eighteenth Century and Nineteenth Century*, London 1970

Sidney Hutchison, *The History of the Royal Academy 1768–1986*, 2nd edn, London 1986

A. MacGregor, 'Collectors, Connoisseurs and Curators in the Victorian Age', *A.W. Franks. Nineteenth Century Collecting and the British Museum*, ed. M. Caygill and J. Cherry, London 1997

Oliver Millar, *The Tudor, Stuart and Early Georgian Pictures in the Collection of Her Majesty The Queen*, London 1963

Oliver Millar, *The Later Georgian Pictures in the Collection of Her Majesty The Queen*, London 1969

Oliver Millar, *The Queen's Pictures*, London 1977

Oliver Millar, *The Victorian Pictures in the Collection of Her Majesty The Queen*, Cambridge 1992

Ian Pears, *The Discovery of Painting. The Growth in the Interest in the Arts in England, 1680–1768*, New Haven and London 1988

Martin Postle, *Sir Joshua Reynolds. The Subject Pictures*, Cambridge 1995

John Pye, *Patronage of British Art, an Historical Sketch*, London 1843

Sir Joshua Reynolds Discourses, ed. with an introduction and notes by Pat Rogers, London 1992

David Solkin, *Painting for Money. The Visual Arts and the Public Sphere in Eighteenth Century England*, New Haven and London 1992

Frances Spalding, *The Tate: A Centenary History*, London 1997

G. Waterfield, 'The Origins of the Early Picture Gallery Catalogue in Europe, and its Manifestation in Victorian Britain', *Art in Museums, New Research in Museum Studies*, 5, ed. S. Pearce, London and Atlantic Highlands 1995

Ellis Waterhouse, *Painting in Britain 1530–1790*. Pelican History of Art, 2nd edn, Harmondsworth 1962, 4th revised edn with an introduction by Michael Kitson, New Haven and London 1994

R. Wendorf, *Sir Joshua Reynolds. Painter in Society*, London 1996

William T. Whitley, *Artists and their Friends in England 1700–1799*, 2 vols, London 1928

William T. Whitley, *Art in England 1800–1820*, Cambridge 1928

William T. Whitley, *Art in England 1821–1837*, Cambridge 1930

HANS HOLBEIN THE YOUNGER (1497/8–1543)

Sir Henry Guildford

The son of a distinguished artist, Holbein first visited London in 1526. His stay lasted two years, during which time this picture was painted, as well as the famous lost group portrait, *The Family of Sir Thomas More*. In 1528 he returned to Germany but was forced to leave due to the iconoclasm that occurred as a result of the Reformation. Holbein then returned to London, becoming painter to Henry VIII and his court, a position he retained until his death. This portrait is one of the few datable works from Holbein's first English visit, being inscribed 1527 on the (repainted) label. The pendant portrait *Mary Wotton, Lady Guildford* is in the St Louis Art Museum, Missouri.

Sir Henry Guildford (1478/9–1532) was an eminent courtier and held several high offices in Henry VIII's household, including that of Comptroller, as indicated by the white staff of office that he carries here. His services to the Crown were rewarded when he was elected Knight of the Garter in 1526 – he is shown wearing the gold collar of the Order. As Comptroller, Guildford was responsible for authorising payments to Master Hans, who is assumed to be Holbein.

Holbein and Guildford were also linked through the philosopher Erasmus, who was the latter's correspondent. Guildford's interest in learning, unusual for a courtier so early in Henry VIII's reign, is also suggested by his hat-badge. This is decorated with a design composed of a clock and surveying instruments – components of an iconographic formula, the 'Typus Geometriae', used in Albrecht Dürer's engraving *Melancholia*.

Holbein's presence in England was to have a significant impact on the artistic sensibilities of those at court, most of whom had never sat to a painter before. His portraits combine verisimilitude with subtlety to a degree that was almost unique in European painting at this date. This painting is lavish in its use of gold and rich contrasting colours such as the juxtaposition of the brilliant green leaves against the blue background and the rich fur collar. However, these areas are visually subservient to Guildford's face, which is placed at the apex of the composition. The fineness of Holbein's technique is as apparent today as it was to his contemporaries owing to the excellent condition of this panel.

A comparison between the preparatory chalk drawing for Henry Guildford's head and this portrait shows that Guildford's face has been appreciably lengthened, making him appear leaner and more authoritative. Holbein's technique of using carefully drawn studies as the basis for oil portraits has left a great legacy in the form of a large group of chalk portrait drawings in the Royal Library at Windsor Castle. K.B.

1
Sir Henry Guildford, 1527
Hans Holbein the Younger,
b. Augsburg 1497/8,
d. London 1543
Oil on panel, 82.6 × 66.4 cm
Inscribed at a later date: *Anno D: MCCCCCXXVII Etatis Suae XL.IX*

LITERATURE
Ganz 1956, no. 44
Millar 1963, no. 28
Rowlands 1985, no. 25

EXHIBITIONS
London, The Queen's Gallery, 1978–9, no. 13
London, The Queen's Gallery, 1988–9, no. 1
Greenwich, National Maritime Museum, 1991, no. V.4

Anno. D. MCCCCCXXVII
Etatis. Sua. xl ix.

33

SIR ANTHONY VAN DYCK (1599–1641)

Cupid and Psyche

This is the only surviving mythological painting by Van Dyck from his years as court artist for Charles I. It is a late masterpiece possibly dating from 1639–40, and was perhaps left unfinished. Although apparently unframed, the painting was hung in the Long Gallery at Whitehall Palace, but its original purpose is not clear. It is possibly connected with Henrietta Maria's commission in the autumn of 1639 for a series of canvases illustrating the story of Cupid and Psyche for her Cabinet in the Queen's House at Greenwich. This project, which involved Jacob Jordaens and Sir Peter Paul Rubens, was never completed – which may explain the painting's lack of frame and finish. On the other hand, the painting may have been made as part of the marriage celebrations of Princess Mary and Prince William II of Orange, April–May 1641. Van Dyck's mistress, Margaret Lemon, may have been the model for Psyche.

Areas of the painting with a higher degree of finish, such as the swirling drapery and the mass of the tree, contrast with thinly painted areas; for example, Cupid's curls and feathers, which are defined with light touches. The free brushwork and poetic rendering of a mythological story show the importance of Titian for Van Dyck, an artist avidly collected by Charles I. The intimacy and tension of the figures result from a number of simple but striking contrasts: the warmth of Cupid's flesh tones and drapery against the coolness of Psyche's skin and cloak; the speed and energy as he barely touches the ground next to the weight of her 'sleeping corpse'. Cupid enters like an Annunciate Angel with hope, whilst she assumes the form of a Dead Christ in a Lamentation. The diagonals of their two bodies are echoed by the dead and living tree beyond, which reinforce the idea of Cupid's touch bringing life back to the dead.

Apuleius's account of the myth of Cupid and Psyche occurs in *The Golden Ass* of the second century AD and was a fashionable story in court life of the 1630s, where it was given a neo-Platonic interpretation. Although mortal, Psyche was so beautiful that Venus was jealous of her and Cupid, her son, fell in love with her. Venus set her a number of tasks, the last of which was to bring to her a small portion of Proserpine's beauty from Hades in an unopened casket. Psyche, overcome by curiosity, opened it and released not beauty but sleep, from which she is gently roused by Cupid. Psyche represents earthly beauty while Cupid is Desire aroused by her beauty. Their marriage symbolises Plato's definition of love in *The Symposium*, 'Love is Desire aroused by Beauty.' Psyche was the Greek name for the soul, here brought back from the dead to heaven by Divine Love. L.W.

2
Cupid and Psyche
Sir Anthony van Dyck, b. Antwerp 1599, d. London 1641
Oil on canvas, 200.2 × 192.6 cm. There are early additions at the upper (9.5–10.8 cm) and lower edge (5.7 cm)

LITERATURE
Millar 1963, no. 166
Strong 1972, p. 62
Parry 1981, pp. 196–7
Brown 1982, pp. 186–7
Larsen 1988, i, pp. 390–1 and ii, p. 409, no. 1043

EXHIBITIONS
London, Tate Gallery, 1972–3, no. 109
London, National Portrait Gallery, 1982–3, no. 58
Washington, National Gallery of Art, 1990–1, no. 85
London, National Gallery, 1991, no. 31

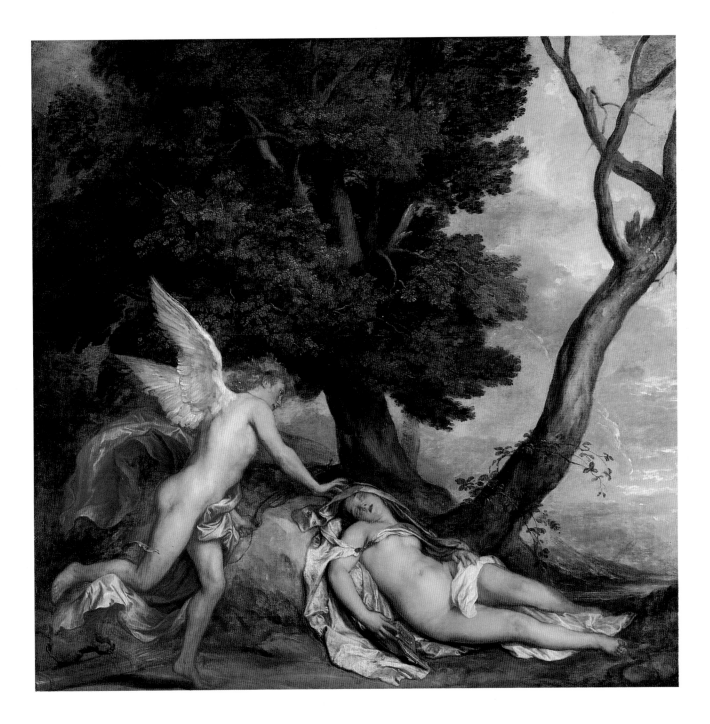

JOHN MICHAEL WRIGHT (1617–1694)

Charles II

This extraordinarily powerful piece is one of the most outstanding examples of the artist's work as well as being a highly unusual and enduring image of monarchy restored. Probably painted in 1661, the King wears St Edward's crown, is dressed in parliamentary robes over the Garter costume and carries the orb and sceptre with cross and a ring on his left hand. He is seated in front of a tapestry which may be a Judgement of Solomon and an oblique reference to the sitter's wisdom.

Opinions differ about the circumstances of the commission of this picture, which has customarily been associated with Charles II's Coronation on 23rd April 1661, partly owing to the emphasis placed on the depiction of the King's regalia. Much of the earlier regalia had been destroyed during the Interregnum and Charles II's crown was made up from the old Imperial crown, whilst the orb and sceptre were made specially by Sir Robert Vyner, the King's goldsmith, for £31,978. 9s. 11d.

However, the painting may date from the end of the next decade, as it may relate to one hung in the Palazzo Doria-Pamphili during a banquet given by the Earl of Castlemaine for the prelates of Rome as a part of an unsuccessful embassy to re-establish the Roman Catholic Church in England. Wright, who accompanied the Earl as steward and designer of the displays for the mission, published a description of the visual theatricals employed, recording that 'opposite to the coming in, was plac'd a Cloth of State, Embroider'd with Gold, under which was the King's Picture, as big as the Life, sitting Crown'd on his Throne, and clad, in his Regal Habit'. A near-contemporary engraving shows a painting remarkably similar to the present one, placed at the banquet as a powerful visual symbol of the absent monarch.

Unusually formal for this date, the picture shows the King in a hieratical pose more commonly seen on seals and coins. However, Wright's portrait also refers to both contemporary French painting, such as Hyacinthe Rigaud's full-length standing image of Louis XIV (Paris, Louvre) and earlier English depictions of monarchs, such as Elizabeth I and Henry VIII. The formality of the King's confrontational position is tempered by the detailed painterly description of his clothing and the elegant asymmetry of his legs and shoes. The silvery-blue highlights, particularly in the sleeves and lace, are typical of the artist's restrained mature style. Charles was 'a tall man, above two yards high, his hair a deep brown, near to black' and had a 'fierce countenance'. These characteristics have been employed by the artist to great effect, creating an enduring image that was a powerful reminder of the antiquity of the monarchy as well as of Charles II's supreme power and physical presence. K.B.

3

Charles II
John Michael Wright, b. London 1617, d. London 1694
Oil on canvas, 281.9 × 239.2 cm

LITERATURE
Millar 1963, no. 285

EXHIBITIONS
Edinburgh, Scottish National
 Portrait Gallery, 1982, no. 28
Edinburgh, Scottish National
 Portrait Gallery, 1989, no. 10

SIR PETER LELY (1618–1680)

Frances Stuart, Duchess of Richmond

After an artistic training in The Hague, Peter Lely arrived in England *c.* 1643, just after the outbreak of the Civil War. His early pastoral landscapes reflect the work of Venetian artists of the sixteenth century, particularly Titian, but he soon moved towards the more lucrative genre of portraiture. In 1661, despite having worked for the Commonwealth, he was appointed Charles II's Principal Painter, beginning a successful career that went almost unchallenged for nearly twenty years.

Much influenced by the works of his predecessor, Van Dyck, Lely formed an important collection of paintings and drawings, including *Cupid and Psyche* (see p. 34), which he purchased from Charles I's collection at the Commonwealth sale. Although Lely's handling of paint and use of colour were never quite as sparkling as Van Dyck's, his paintings have a rich texture and fluid virtuoso quality. They are often very flattering, and many of his female sitters are shown in fashionable undress gowns – revealing satin robes made of sumptuous fabrics which were particularly well suited to portraiture as they gave the sitter an air of timeless, luxurious negligence.

Lely was a skilled draughtsman and many delicate chalk studies of the faces and hands of his sitters survive. These reflect his studio practice of employing assistants to paint large areas of some of his works while he concentrated on important details, and explain the immense variety in the quality of work ascribed to Lely.

Frances Stuart (1648–1702), daughter of Walter Stuart of Blantyre, became Lady of the Bedchamber to Catherine of Braganza, the wife of Charles II. A renowned beauty, she rejected the advances of many suitors and was Charles II's particular favourite. She eloped with Charles Stuart, third Duke of Richmond and sixth Duke of Lennox, and they were secretly married in March 1667. In 1668 she caught smallpox, which it was said greatly disfigured her, but she remained at court. Frances was chosen as the model for Jan Roettier's figure of Britannia, which relates to the figure still used on modern coinage, in the *Peace of Breda* medal of 1667.

The Duchess is shown carrying a hunting bow – an attribute of the goddess Diana – although it is not clear whether Lely was intending the image to be understood as allegorical. The painting is full of contrasts – between the vigorously painted acid-yellow folds of the creases in the dress and the delicate handling of the chestnut hair, and between the pink-tinged whiteness of the sitter's skin and the forested landscape behind her head in which the darkening sky reflects the colours of her dress. K.B.

4
Frances Stuart, Duchess of Richmond, 1662–1665
Sir Peter Lely, b. Westphalia 1618, d. London 1680
Oil on canvas, 125.8 × 102.7 cm

LITERATURE
Millar 1963, no. 258

EXHIBITION
London, National Portrait Gallery, 1979

SIR PETER LELY (1618–1680)

Henrietta Boyle, Countess of Rochester

This picture and the previous work were painted by Lely for Anne Hyde, Duchess of York. They form part of a set of eleven works known as the Windsor Beauties. A contemporary account states that 'the Duchess of York wished to have the portraits of the most beautiful women at Court. Lely painted them, devoted all his powers to the task and could not have worked on more lovely subjects.' Painted between 1662 and 1665, the eleven pictures represent Lely's mature style at its finest. The sitters are all shown three-quarter length, wearing richly coloured undress gowns and often carrying attributes. They are placed next to a piece of statuary or curtain in front of an unspecific landscape, which in this portrait is particularly atmospheric in its lighting. The group of portraits forms one of the greatest sets of paintings produced in England during the seventeenth century, inspiring the Hampton Court Beauties by Kneller (see p. 44).

The sitter is Henrietta Boyle, Countess of Rochester (1646–87), the daughter of Richard Boyle, first Earl of Burlington. In 1665 she married Lawrence Hyde, first Earl of Rochester, and she was governess to Princess (later Queen) Anne in 1677 and 1682. This painting is especially remarkable for its luminous, almost sugary, colour. The rich blue impasto of the Countess's heavy satin dress is contrasted by harmonious highlights of reds throughout the picture, particularly in the roses that she carries in her pink fingers, the areas of shadow under her left arm and the sunset behind. These tones culminate in the reds of her lips at the centre of the composition.

An examination of the brush-strokes of the sitter's left hand demonstrates Lely's rapid painting technique. Here, red under-painting is used to create the area of shadow around the fingers and to suggest the foreshortened ends disappearing into the fabric. The deepest creases of the stiff purplish cloak are suggested by a series of swift dark strokes, whilst parallel whitish strokes are used to show the highlights in the fabric. In contrast, the face and hair are painted with great care. It was perhaps this ability both to generalise and yet also to capture the individuality of his subject that was Lely's main talent. Like the Duchess of Richmond (p. 38), the Countess of Rochester gazes out from under slightly closed eyes, allowing the viewer to perceive in her a sense of femininity and vulnerability. K.B.

5

Henrietta Boyle, Countess of Rochester, 1662–1665
Sir Peter Lely, b. Westphalia 1618, d. London 1680
Oil on canvas, 124.4 × 101.4 cm

LITERATURE
Millar 1963, no. 262

EXHIBITION
London, National Portrait Gallery, 1979

JOHN RILEY (1646–1691)

Prince George of Denmark

Riley emerged as the leading court portraitist during the period between Lely's death in 1680 and the ascendancy of Kneller, with whom he was appointed joint Principal Painter to William III and Mary II in 1688. Little is known about his early career except that he trained under the Dutch artist Gerard Soest. His first portrait commission from Charles II was unsuccessful and the King is said to have remarked on it, 'Is it like me? Then oddfish, I am an ugly fellow!' Despite this, Riley rose to prominence in the 1680s, becoming the first nominated steward of the Rose and Crown Club, an artists' society from which the academies of the next century developed; 'being much indisposed of an illness of which he died', his place was taken by his collaborator John Closterman.

Riley holds an important place in the development of English portraiture, forming a link between his former master Lely and his pupil Jonathan Richardson the Elder to Thomas Hudson, the first teacher of Sir Joshua Reynolds. Although he inherited at least a part of Lely's clientele, his uncourtier-like temperament was better suited to painting more modest sitters, as in his well-known depiction of James II's 'necessary woman', Bridget Holmes (Royal Collection).

The present picture is probably referred to by Queen Anne in a letter to her sister Mary, written from Richmond on 11th April 1687: 'I must tell you that the Prince has sat once for his picture, and if I can get the man to come hither it shall be made more out of hand'. It is described as hanging over the mantel in Queen Anne's Bedchamber in the Garden House at Windsor.

Prince George of Denmark was the younger brother of Christian V of Denmark. He married Queen Anne in 1683 and was described by the diarist John Evelyn as having 'the Danish Countenance, blound; a young man of few words, seemed somewhat heavy; but reported Valient'. He is shown in semi-classical costume, wearing a breastplate with the ribbon of the Garter and holding a baton. This military image was appropriate to his position as Lord High Admiral and generalissimo of land and sea forces, to which he was appointed on his wife's accession in 1702. Although he was nominally senior to his close friend the Duke of Marlborough, it was the latter who was responsible for the great military victories against the French in 1702.

This popular portrait was copied on numerous occasions. The sitter's conventional pose is relieved by the slight twist in his posture and by his elbow, which protrudes out of the picture surface in the foreground. He has an appealing air of nonchalance, which does not accord with accounts of him as a shy, physically weak man.

K.B.

6
Prince George of Denmark
(1653–1708)
John Riley, b. England 1646,
d. London 1691
Oil on canvas, 126.4 × 102.5 cm

LITERATURE
Millar 1963, no. 329

SIR GODFREY KNELLER (1646?–1723)

Margaret Cecil, Countess of Ranelagh

One of eight portraits known as the Hampton Court Beauties and commissioned by Mary II after 1690, this is an example of Kneller's mature style. Kneller arrived in England by 1676, at a time when there were few artistic rivals to him at court. He painted official portraits of successive sovereigns and their consorts, and was appointed Principal Painter by William III and Mary II, knighted in 1692 and created a baronet in 1715. This artistic supremacy was reflected in his luxurious lifestyle and large studio practice.

The Beauties were described by Daniel Defoe as 'the principal Ladies attending upon her Majesty, or who were frequently in her Retinue ... this was the more beautiful sight because the originals were all in being and often to be compared with their pictures'. The set of paintings, which may have originally numbered twelve, hung first in the Water Gallery at Hampton Court Palace, which had been redecorated for Queen Mary by Sir Christopher Wren and Grinling Gibbons.

Kneller's Beauties are depicted as full lengths in loose undress gowns similar in conception to Lely's (see pp. 38–41). However, they convey a very different tone from Lely's sensuous characterisations and appear more formal and remote. This is partially a result of their larger scale, which lends the figures a statuesque, theatrical air more akin to Van Dyck's full lengths, also an important visual source for Kneller. Like the Lely portraits, the figures are often posed in front of a sculpted relief, with a landscape background. It is not clear whether the pictures have an allegorical significance or whether they are simply charming, wistful portraits reflecting the interest in Arcadianism at court.

Kneller's legacy was long lasting and his influence is apparent on later artists – including Sir Joshua Reynolds (see p. 58), who purchased Kneller's *Self Portrait* and whose majestic full lengths clearly owe a great deal to the Beauties in form and conception. Henry Fielding describes his heroine Sophia Western in *Tom Jones* (published in 1749) as 'most like the picture of Lady Ranelagh'. The Beauties represent the transition from the work of Van Dyck to that of Reynolds in that they capture the new air of sensibility that began to dominate behaviour and appearance at court.

The Countess of Ranelagh (1672–1728) was the third daughter of the Earl of Salisbury; she married Richard Jones, first Earl of Ranelagh. This image of her is remarkable for its subtle grandeur as she gazes directly at the viewer but gestures outside the composition. Similarly, her body is hidden by the curving drapery of her dress, which enhances the statuesque quality of her form. The composition centres around a series of curves – the curtain echoes the folds of the skirt and the whiteness of the Countess's shoulders is heightened by a curl of hair. K.B.

7
Margaret Cecil, Countess of Ranelagh
Sir Godfrey Kneller, b. Lübeck 1646?, d. London 1723
Oil on canvas, 232.9 × 143.6 cm
Signed (indistinctly): *Godfrid : Kneller F.*

LITERATURE
Millar 1963, no. 356
Douglas Stewart 1983, no. 601

33
COUNTESS of RANELAGH.

KNELLER.

MARCELLUS LAROON THE YOUNGER (1679–1772)

Dessert Being Served at a Dinner Party

One of the first practitioners of the rococo style in England, Marcellus Laroon travelled to The Hague and Venice in his youth before becoming a singer at the Drury Lane Theatre, London. A long career in the army followed this and it was not until retirement that Laroon took up painting for pleasure. His financial independence enabled him to paint subjects of his own choosing rather than undertaking more lucrative work such as formal portraiture, and consequently he was one of the first artists in England to develop the more domestic relaxed mode of the 'conversation piece'. This painting, dating from about 1725, is a very early example of that genre. Laroon wrote that he gave it to George II, although it is not recorded at Kensington Palace until 1818.

Laroon's work is very similar to that of French contemporary painters such as Jean-Antoine Watteau in its use of pale sugary colours and delicate forms. He was also influenced by the paintings that he saw in Venice as a young man and by the contemporary taste for Dutch seventeenth-century genre paintings by artists such as David Teniers the Younger – which can be seen in his robust characterisations of the servants in this painting. There has been a great deal of speculation about the identity of the sitters in this picture and it has been suggested that the main figure wearing the Garter sash is Frederick, Prince of Wales. However, this is impossible, and it is still not known if the figures are actual people. Many of the faces and gestures tend towards caricature and it is tempting to imagine that very few, if any of them, are portraits.

Laroon's stage career is also apparent in his work, which often has a theatrical air. For instance, his inclusion of the curtain falling across the right-hand corner of this composition gives the impression that the unseen viewer is being allowed a secret glimpse of the scene it reveals. The audience is drawn into the composition by the young servant in the foreground who gazes directly at the viewer. Other compositional devices include the man playing with the dog in the foreground; his bent pose enables the viewer to see the fashionable lady behind him.

Laroon clearly took a great interest in contemporary manners and morals and this picture has an engaging and ironic air. It is full of incident and charm, from the ruddy parson's comfortable expression to the flirtation between the couple to his right. It also contains many finely painted passages, such as the small still life of glasses on the table to the left and the way that the shaft of wine breaks up into minute drops as it is elegantly poured by the central male figure.　　K.B.

8
Dessert Being Served at a Dinner Party
Marcellus Laroon the Younger,
b. Chiswick 1679, d. Oxford 1772
Oil on canvas, 90.8 × 85.8 cm

LITERATURE
Millar 1963, no. 520
Raines 1967, no. 1

EXHIBITIONS
Aldeburgh, Aldeburgh Festival,
 1967, no. 1
York, Fairfax House, 1996, p. 23

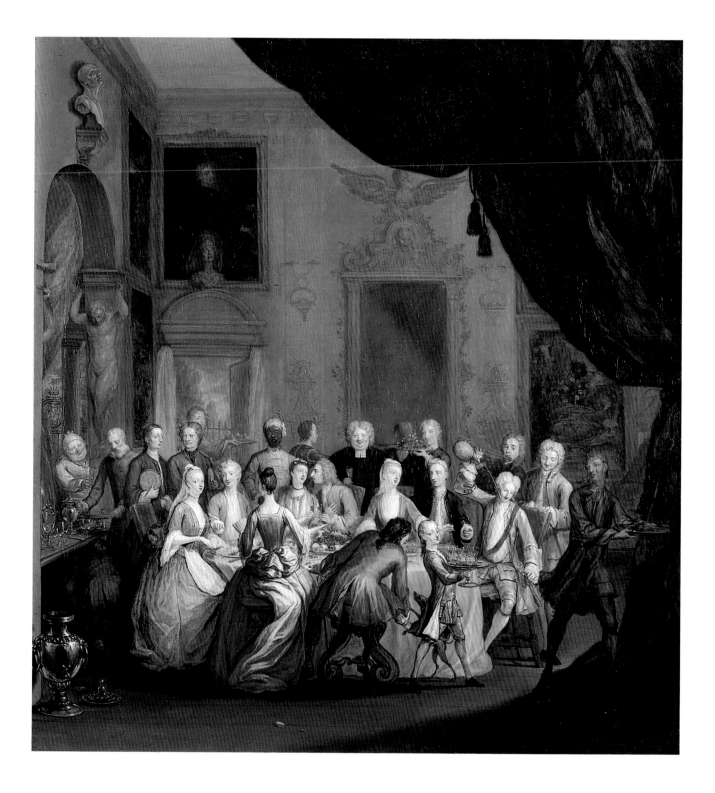

JACOPO AMIGONI (c. 1682–1752)

Frederick, Prince of Wales

An itinerant artist, Amigoni spent the years 1730–9 in England, painting portraits and decorative schemes. Vertue described his work as 'having a pleasant invention and disposition of draperyes. his mixture of little Cupids the tenderness of colouring all together had something pleasant and new that the courtiers and quality. pressd. Him, to imploy him in portraits', but said he had 'a reluctance' to do this, preferring history painting and the 'money therefrom'. Amigoni's work has a rococo flavour reflecting his training and early career in Venice and at the Bavarian court. This was to prove attractive to the English court and he was patronised by various members of the English royal family, including Queen Caroline, the wife of George II.

Amigoni painted three portraits of Frederick, Prince of Wales, in 1735. This example is perhaps the work costing £42 that was given to George Bubb Dodington, later Lord Melcombe, the Prince's chief political adviser from 1731. It was in Carlton House by 1816, probably having been purchased by his grandson George IV. Frederick was particularly aware of the power of the royal image and often used portraiture for political ends. He sat for over seventy portraits, most of the resulting images being given away (see p. 52).

Here the Prince is portrayed as both warrior and scholar in an image replete with references to his interests and ambitions. An allusion to his (unrealised) military career can be seen in the breastplate that he wears under his fashionable coat. His patronage of architecture and the arts is perhaps indicated by the classical interior and the carved gilded table at which he sits. The two putti are intended to represent the Arts and Sciences – one of them holds a lyre and the other the snake of Wisdom – whilst the book in the Prince's right hand is inscribed *Pope's Homer*. Frederick had entertained Alexander Pope and was a supporter of the author, whose *Rape of the Lock* and translations of Homer made him the foremost literary figure of the day.

The composition is divided into two distinct areas: the pyramidal mass of the Prince and the contrasting shape of the two putti. However, these are linked by the sitter's left hand and by the repetition of colour – for instance, the blue of the fabric on the table is reflected in the Garter ribbon and the putti's swirling drapery. This picture is particularly continental in its colouring and effusive handling. Its iconographic allusions and rococo flourishes to some extent anticipate later Grand Tour portraits by artists such as Pompeo Batoni.　　K.B.

9
Frederick, Prince of Wales, c. 1735
Jacopo Amigoni, b. Naples c. 1682,
d. Madrid 1752
Oil on canvas, 128.3 × 106.7 cm

LITERATURE
Woodward 1957, pp. 21–3
Millar 1963, no. 526
De-la-Noy 1996, p. 198

EXHIBITIONS
London, The Queen's Gallery,
　1977, no. 27
Sudbury, Gainsborough's House,
　1981, no. 5
London, The Queen's Gallery,
　1982–3, no. 58

WILLIAM HOGARTH (1697–1764)

The Popple and Ashley Families

Hogarth's early success with theatrical paintings, such as *The Beggar's Opera* of 1728 (London, Tate Gallery), came to colour his approach to fashionable pictures such as this one – small-scale informal conversation pieces that were inspired by French painting. He gave such compositions greater credibility than the stiffly regimented groupings his contemporaries had. 'Subjects I consider'd as writers do; my Picture was my Stage and men and women my actors,' he wrote in an analogy between painting and the theatre. He was also unique in striving to express action and emotion, not only through the conventionally accepted canon of gestures as laid down in academic pattern books, but through instances of sharply observed natural movement.

After initial successes as an engraver and painter of theatrical themes, Hogarth began to receive more commissions for conversation pieces than he could cope with. Realising that the labour in producing these was not commensurate with the fees that they commanded, he turned to the production of the engraved sets of prints after originals of his own invention for which he is best known. *The Popple and Ashley Families* was painted just before Hogarth turned his attention to one of his most famous 'modern moral subjects', *The Harlot's Progress*.

Despite his appointment as Serjeant-Painter in 1757, Hogarth was never really patronised by the Crown and only a preliminary *modello* survives of his one attempt to paint the royal family (Royal Collection). The present picture did not enter the Collection until 1887, when it was bequeathed to Queen Victoria.

Although the identification of the figures is uncertain, the seated figure on the right bears some resemblance to other portraits of Alured Popple (1698–1744), a future Governor of Bermuda, whilst the man in the centre is probably his brother William, a minor dramatist who succeeded him. The seated female figures presumably represent Alured's wife Mary and his aunt Katherine, who had married into the Ashley family. The child in the foreground is Marianne, Alured's daughter. The owl is presumably included because it featured in the Popple family crest.

The figures give the impression of having been painted before the background was added and of having been adjusted at a later stage. For instance, the seated woman on the left originally had her hand in her lap; it was moved to her companion's shoulder later on. The composition is typical of Hogarth's earlier conversation pieces in that it consists of two pyramidal groups with an empty, inverted pyramid-shape space between them, closed in on either side, like a stage set. The groups are almost connected by the parallel lines of the stick and fishing line but are left tantalisingly separate. This is emphasised by the two central figures, who face away from each other, creating two visual focuses and emphasising the complex interrelationships between the protagonists. K.B.

10
The Popple and Ashley Families, 1730
William Hogarth, b. London 1697, d. London 1764
Oil on canvas, 63.0 × 75.2 cm
Signed and dated: *W^m Hogarth: pinx^t 1730*

LITERATURE
Millar 1963, no. 561
Paulson 1992, pp. 212–13

Attributed to CHARLES PHILIPS (1708?–1747?)

Frederick, Prince of Wales

Born and educated near Hanover, Frederick, Prince of Wales, was the eldest son of George II and Queen Caroline. He did not take up residence in England until 1728, and soon after became an opponent of his father's political allies and court circle. The relationship between the Prince and his parents gradually deteriorated until the former was forced to leave his official apartments in St James's Palace, establishing himself independently in Leicester House on Pall Mall. Frederick and his wife Augusta (see p. 54) both took a great interest in the arts and promoted the work of various artists and writers. He formed a significant collection of paintings which he showed in 1745 to the antiquarian scholar George Vertue, who subsequently stated that 'no prince since King Charles the First took so much pleasure nor observations on works of art or artists'. Frederick also commissioned elegant frames to surround his paintings and concerned himself with their restoration.

This picture was probably executed soon after the marriage of the Prince and Princess of Wales on 27th April 1736. Although formerly attributed to William Hogarth (see p. 50), both this portrait and its companion piece (see p. 55) appear after recent cleaning to be by the artist Charles Philips; they are stylistically close to known works by Philips, particularly a comparable full-length portrait of the Prince of Wales, signed and dated 1731 (New Haven, Connecticut, Yale Center for British Art). Vertue remarked of Philips that 'in painting small figures portraits & conversations [he] has met with great encouragement amongst People of fashion – even some of ye Royal Family'. A successful artist, particularly in the Prince of Wales's circle, Philips specialised in small-scale portraits and conversation pieces in the style of Arthur Devis. He consciously, although unsuccessfully, emulated the work of the French artist Jean-Antoine Watteau, but his best work has a rococo charm and simplicity that was lost when he began to paint full-scale portraits towards the end of his career as the fashion for smaller images disappeared (for instance, the full length of the Prince also in the Royal Collection).

This portrait shows the Prince of Wales in Garter robes with the plumed hat of the Order resting on the gilt table behind him. He rests his right hand on an elaborately carved armchair which carries the Prince of Wales's feathers and behind him is a statue of Minerva, goddess of Wisdom. Above the Prince two putti lift up the edge of a hanging curtain, a feature that might have been inspired by the work of Amigoni (see p. 48), who often employed flying putti as a decorative device – and as another of the Prince's favourite artists his work would have been known to Philips. K.B.

11
*Frederick, Prince of Wales, c.*1736
Attributed to **Charles Philips**,
b. London 1708?, d. London 1747?
Oil on canvas, 76 × 50.8 cm

LITERATURE
Millar 1963, no. 562

EXHIBITIONS
London, Tate Gallery, 1971–2,
 no. 99
London, Courtauld Institute, 1997,
 no. 56

Attributed to CHARLES PHILIPS (1708?–1747?)

Augusta, Princess of Wales

A companion piece to Philips's portrait of Frederick, Prince of Wales (see p. 52), this image shows Princess Augusta of Saxe-Coburg soon after her arrival in England and marriage to the Prince. Despite the marriage having been arranged, their relationship was extremely successful and they had seven surviving children, their eldest son being the future George III.

Accounts of the Princess's appearance and behaviour on her arrival in England vary. According to the Earl of Egmont, one of Frederick's supporters, she had 'a peculiar affability of behaviour and a very great sweetness of countenance mixed with innocence, cheerfulness and sense'. However, Lord Hervey, Queen Caroline's closest adviser, who had quarrelled with the Prince and become his opponent, described her as 'rather tall ... and had health enough and youth enough in her face, to make her countenance not disagreeable; but her person, from being very ill-made, a good deal awry, her arms long, and her motions awkward, had, in spite of all the finery of jewels and brocade, an ordinary air, which no trappings could cover or exalt'. All contemporary commentators agree on the 17-year-old Augusta's innocence at her marriage, at which time she spoke only German. However, she was soon able to establish herself at the centre of a group of cultured Whig aristocrats whose political causes were promoted by her husband.

This image shows Augusta in robes of state with the Princess of Wales's coronet prominently displayed in the foreground held by a putto. This device reappears in the clouds in Philips's large-scale portrait of Augusta at Warwick Castle. As in its companion piece of the Prince of Wales, the handling of the paintwork, particularly the still life of fruit and flowers in this picture, seems to lack Hogarth's fluidity and assuredness of touch and it is most likely that the picture is by his contemporary Charles Philips, who also painted the official portrait of the Princess in the Royal Collection. The circumstances of the commission of the companion portraits are unknown, and it is possible that both works were either studies for larger official portraits or later copies by Philips of larger portraits.

This picture appears to be on a canvas that had originally been painted as a landscape format conversation piece – a genre for which Philips was well known. A pentimento of a smiling man's head is clearly visible above the tassels on the upper left corner of the canopy that hangs above Augusta's head.

K.B.

12
Augusta, Princess of Wales, c. 1736
Attributed to **Charles Philips**,
b. London 1708?, d. London 1747?
Oil on canvas, 75.9 × 50.9 cm

LITERATURE
Millar 1963, no. 563
De-la-Noy 1996, pp. 138–40

EXHIBITIONS
London, Tate Gallery, 1971–2,
 no. 100
London, Courtauld Institute, 1997,
 no. 57

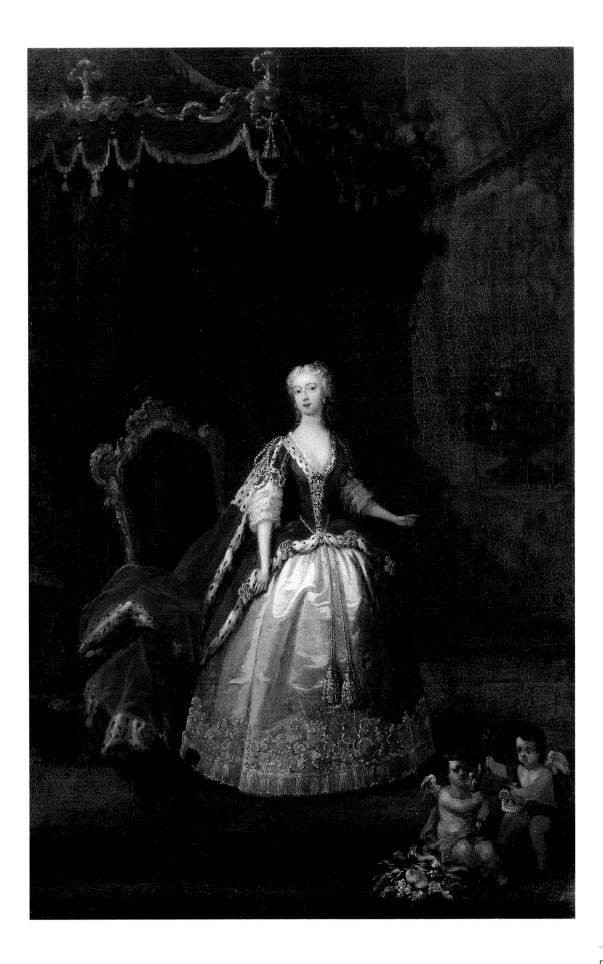

ALLAN RAMSAY (1713–1784)

Queen Charlotte with her Two Eldest Sons

Ramsay combines the large scale and impressive setting of a State Portrait with a candid portrayal of a family group. The Queen holds Prince Frederick, later Duke of York, and Prince George, later George IV, is at her knee. The painting can be dated *c.* 1764 on the basis of the ages of the children, but Ramsay received payment as late as February 1769, which suggests that completion was delayed.

Ramsay was Principal Painter to the King following George III's accession to the throne in 1760, and much of his time was taken up with producing copies of the State Portraits made at the time of the Coronation. The Queen's head and the two children are painted on separate pieces of canvas sewn into the main canvas. The use of such insertions was part of Ramsay's painting procedure, neatly dealing with the logistical problem of taking an initial likeness from life before completing the portrait in the studio, perhaps over a long period of time, aided by drawings and lay figures. The final composition was carefully planned from the start. Several preparatory studies have survived – including studies of the hands and arms, to which Ramsay always paid close attention. The Queen's head is turned slightly at the apex of the pyramid formed by the three sitters. This key position, enhancing her plain features, establishes their place in front of the curve of the plinth supporting the double columns. The setting and the highly finished surface point to the influence of Italian art, but the delicate pastel shades of pink, green and blue of the sitters' clothes, and the direct intimacy of Ramsay's approach, show the effect of contemporary French art, particularly the State Portraits by Carle van Loo and his nephew Louis-Michel. Typical of his portraits of this date is the way in which these colours are held in place by the restrained lighting and underlying grey modelling, the flesh enlivened by small touches of vermilion. The relaxed attitude of the family may in part be because, unlike Reynolds, Ramsay was on close terms with the King and Queen, conversing with the Queen in her native German. In addition, contained within the rigorous composition are informal and domestic details: the ball clasped by Prince Frederick, the bow, the toy drum, the portfolio propped up against the spinet upon which at a casual angle lies a workbasket. John Locke's *Some Thoughts Concerning Education* (1693), laying on top of the spinet, was widely read as advice for parents on raising a son. The toys are a reminder that the King and Queen enjoyed the company of their children and seeing them at play, the book conveys that they were heeding Locke's belief that education was the crucial formative influence, not only for the individual but for the nation.
L.W.

13
Queen Charlotte with her Two Eldest Sons
Allan Ramsay, b. Edinburgh 1713, d. Dover 1784
Oil on canvas, 247.8 × 165.0 cm. The Queen's head and the two children are painted on three separate and contiguous pieces of canvas sewn into the main canvas

LITERATURE
Millar 1969, no. 998
Smart 1992, pp. 184–7

EXHIBITION
Edinburgh, Scottish National Portrait Gallery and London, National Portrait Gallery, 1992–3, no. 186

SIR JOSHUA REYNOLDS (1723–1792)

The Death of Dido

Reynolds exhibited this major history painting at the Royal Academy in 1781, and at a late stage in his career it was the test-case for his ideas about the 'Grand Style' of painting. In Virgil's fourth book of the *Aeneid*, Aeneas, as instructed by Jove, has set sail at dawn, abandoning the distraught Dido, Queen of Carthage. Her sister Anna, believing that Dido is about to execute a magic rite, follows her instructions and builds a funeral pyre on which Dido lays Aeneas's arms, robes and portrait (here a small statue) and their bridal bed. Dido climbs onto the pyre and falls on Aeneas's sword. The grief-stricken Anna rushes to embrace her dying sister while Juno sends Iris, who 'drew a thousand colours from the light', to cut a lock of Dido's hair and release her soul from its agony.

Reynolds argued in his *Discourses*, the fifteen lectures on art delivered at the recently founded Royal Academy, that in order to represent true beauty the artist had to seek the archetypal idea of beauty within nature from which all individual forms deviate. One of the best ways was to imitate the great masterpieces, in particular those of the ancient world, early sixteenth-century Rome and seventeenth-century Bologna, many of which Reynolds would have seen when he travelled in Italy 1750–2. The Bolognese School based their style on borrowing ideas from different masters and here Reynolds's composition looks back to the Bolognese Guercino's *Herminia Discovering the Wounded Tancred* (1618–19, Rome, Galleria Doria-Pamphili) and *Dido Transfixed with the Sword of Aeneas* (c. 1631, Rome, Palazzo Spada). Reynolds transforms the sixteenth-century Roman artist Giulio Romano's frescoed figure of Psyche in deep sleep (Mantua, Sala di Psyche, Palazzo del Tè) into the figure of Dido now caught in the agony of death. He may have been aware that Psyche was derived from the antique sculpture known as *Cleopatra* (Rome, Vatican Museums). The figure of Anna was probably adapted from a lamenting woman in Daniele da Volterra's fresco *Descent from the Cross* (Rome, Santa Trinità dei Monti).

The artist Henry Fuseli recounts the care Reynolds took with the painting and the 'throes which it cost the author'. The painting had a mixed reception at the Royal Academy, and it remained unsold at Reynolds's death. The most important of the twelve recorded copies known today is the version in the Philadelphia Museum of Art. Restrained by its eminent Italian sources, Reynolds's painting never enters the strange imaginary world of Fuseli, who in the 1781 Royal Academy exhibition included two works which were deeply indebted to Reynolds's painting: his own *Death of Dido* and the more famous *Nightmare*, a central work in the European Romantic movement. L.W.

14
The Death of Dido
Sir Joshua Reynolds, b. Plymton
1723, d. London 1792
Oil on canvas, 147.5 × 239.2 cm

LITERATURE
Millar 1969, no. 1029
Dorment 1986, no. 83
Postle 1995, pp. 187–92

EXHIBITIONS
London, Royal Academy, 1986,
no. 123
London, The Queen's Gallery,
1994, no. 8

SIR JOSHUA REYNOLDS (1723–1792)

Self Portrait

Reynolds painted this arresting image of himself wearing spectacles in about 1788 at the age of 65. Like Rembrandt, whom he much admired, Reynolds painted numerous self portraits, reflecting the artist's aspirations and preoccupations at each stage in his career. Reynolds wore silver-rimmed spectacles from 1782, when he suffered 'a violent inflammation of the eyes'. The two surviving pairs show that he was short-sighted and would have needed them to see his sitters. In July 1789 Reynolds noted that his left eye 'began to be obscured'; by January 1790 he was wearing spectacles with one glass opaque and by 1791 he was almost completely blind. This is the only self portrait showing the artist wearing spectacles, and they are the most striking element in the painting. He could probably see his own image close up in a mirror without them and in his last self portrait painted shortly afterwards his pose and expression are very similar, but there are no spectacles. Here Reynolds makes a virtue of his failing physical powers, just as his earlier image (c. 1775, Tate Gallery) is made more dramatic by the cupping of his hand to his ear that highlights his deafness.

Reynolds is fashionably but modestly dressed, his wig is slightly curled to resemble his own hair. His first biographer Edmond Malone described this self portrait as 'extremely like him' and 'exactly as he appeared in his latter days, in domestick life'. He was never regarded as handsome. Cornelia Knight's comment that 'his features were coarse, and his outward appearance slovenly' is moderated by Malone: 'in stature rather under middle size, of a florid complexion and a lively and pleasing aspect; well made and extremely active'. Reynolds was the most intellectual artist of the eighteenth century, a close friend of Dr Johnson and part of a literary circle that also included Edmund Burke, Oliver Goldsmith, Edward Gibbon, Adam Smith and David Garrick. As in many other self portraits, Reynolds excludes the tools of his trade. Instead we see an energetic man turning towards us, his head caught in strong light against the dark background, as in Rembrandt's portraits. The parted lips, direct gaze and above all the spectacles indicate an alert, intelligent mind. This painting pleased Reynolds, who gave versions to his friends, and was a popular image of him. The fact that a contemporary copy was acquired by George IV on 4th June 1812 possibly spurred on Mary Palmer, Marchioness of Thomond and Reynolds's niece, to give 'the best portrait he ever painted of himself' to the Prince (letter, 20th June 1812) – who, unlike his father, had been Reynolds's great patron 'and may I presume to say his friend'. L.W.

15
Self Portrait
Sir Joshua Reynolds, b. Plymton 1723, d. London 1792
Oil on panel, 75.1 × 63.4 cm

LITERATURE
Millar 1969, no. 1008

EXHIBITIONS
London, Royal Academy, 1986, no. 149
Cardiff, National Museum of Wales, 1990–1, no. 41
Plymouth, Plymouth City Museums and Art Gallery, 1992, no. 22
London, The Queen's Gallery, 1994, no. 66

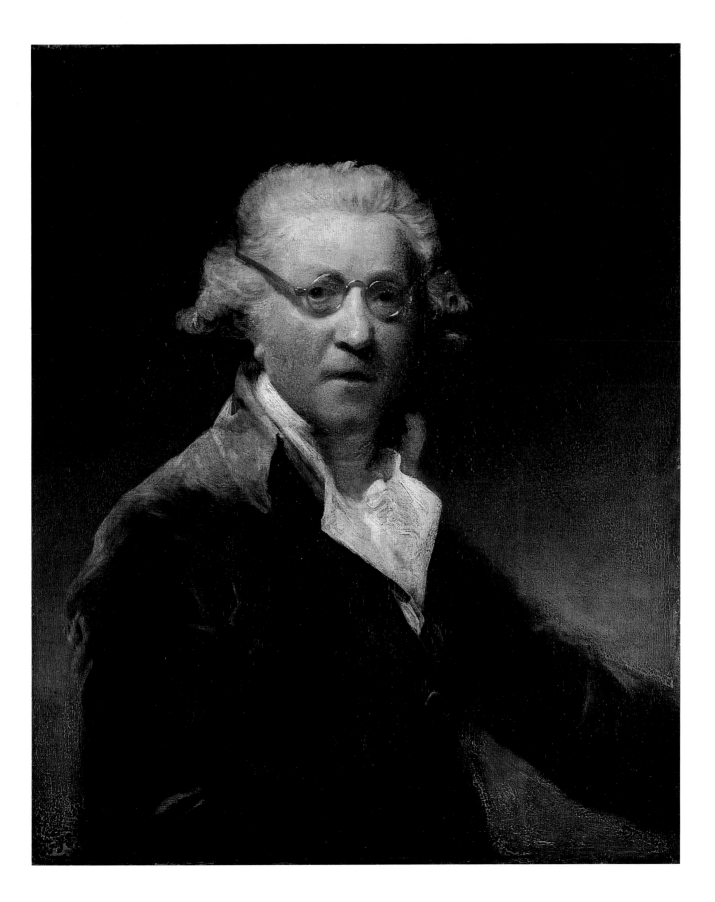

JOSEPH NICKOLLS (active 1726–1755)

St James's Park and The Mall

The painted urban prospect, especially one that was focused on public and social spectacle rather than topography, became an established genre during the eighteenth century, having been introduced by foreign artists such as the Venetian Marco Ricci, who painted St James's Park from a similar viewpoint to this in about 1710 (Washington, National Gallery of Art). Very few works – all of them London views – can be attributed to Nickolls, about whom little is known. He was involved in a decorative scenery design of 'a beautiful landscape painting of ruins' at the Vauxhall Pleasure Gardens. It is clear that he was a skilled artist in the Dutch townscape tradition, and most probably he produced more works than are known at present. His treatment of light and atmosphere come close to that of the well-known view painter Samuel Scott, whilst his lively carefully observed figures are closer to Hogarth (see p. 50) or Hubert-François Gravelot.

Nickolls's delight in humanity can be seen in this picture, which combines topographical accuracy with gentle humour and detailed observation. It shows the east end of The Mall, with Westminster Abbey in the distance and Horse Guards Parade on the left. At this time The Mall was raised and boarded in for the game of pall mall, a type of croquet played on a surface made of pulverised cockle shells. The canal created by Charles II in 1660, when St James's Park was first opened to the public, can be seen in the middle distance.

This view of c. 1745 gives a wonderful impression of one of the favourite pastimes of the London public throughout the century, that of promenading in The Mall in the French style. The entire range of the social scale is carefully represented: the stout figure of the man seen from behind on the left, wearing a hat and the ribbon of the Garter, is probably George II. The prominent group in the foreground, just off centre right, is led by his son, Frederick, Prince of Wales (see pp. 49, 52), with companions who may include the first Duke of Newcastle, wearing the riband and star of the Garter. Despite the presence of royalty and nobility, St James's Park had an ambivalent reputation, as an account of 1725 describes: 'the park is so crowded at times that you cannot help touching your neighbour. Some people come to see, some to be seen, and others to seek their fortunes; for many priestesses of Venus are abroad ... all on the look-out for adventures.' While people of fashion parade under the trees in a parody of the graces of shepherds and shepherdesses, others – including soldiers, clergymen and milkmaids with their cows – mingle on the edges of the scene. K.B.

16
St James's Park and The Mall
Joseph Nickolls (active London 1726–55)
Oil on canvas, 104.1 × 138.4 cm

LITERATURE
Millar 1963, no. 617

EXHIBITIONS
London, Museum of London, 1987, p. 81
London, Tate Gallery, 1987–8, no. 114
Wellington, Museum of New Zealand Te Papa Tongarewa, 1994–5, no. 20

GEORGE STUBBS (1724–1806)

Laetitia, Lady Lade

Almost all of the eighteen paintings by Stubbs in the Royal Collection were commissioned or acquired by George, Prince of Wales (later George IV), during the 1790s. This is one of a group of eight pictures remaining in their original identical frames, made by Thomas Allwood for £110.16s.0d in 1793. It hung in the Prince's main London residence, Carlton House, in 1816.

Laetitia Darby, later Lady Lade (d. 1825), had obscure origins. Reputedly the mistress of the highwayman John Rann, she met the Prince of Wales at a masquerade in 1781 and confessed her love for his brother, Prince Frederick, Duke of York. The Prince of Wales recounted the meeting to the latter: 'I believe no woman ever loved a man more passionately than she does you. She cried very much.' By 1787 she had married Sir John Lade, who was reputed to have met her 'at a house ... whose inhabitants were not endowed with every virtue'. A member of the Jockey Club, Sir John was a friend of the Prince of Wales, to whom he sold horses. *The Times* of 5th August 1789 criticised the Prince's public acknowledgement of Lady Lade, 'a woman who lived in the style of a mistress to one-half of his acquaintance'. Although moved by her notoriously bad language to coin the phrase 'to swear like Lady Lade', the Prince ignored her critics and granted the Lades an annual pension of £300.

Set in either St James's Park (see p. 62) or Kensington Gardens, this painting displays the considerable skills of the rider, who is seated side saddle, controlling her spirited horse with a whip and restraining rein running from the bridle to the saddle. It was most unusual for a woman to be depicted riding at this date, particularly in control of an obviously agitated steed, and it is perhaps indicative of Lady Lade's forceful personality that she should be shown in such a dominant position.

Trained as an animal painter and anatomist, Stubbs was able to achieve a harmony of form rarely seen in animal painting. This composition is deceptively simple, the horse and rider being counterbalanced by the overhanging branches opposite. However, the placement of the horse in the right half encourages the viewer to imagine its movement and to anticipate its journey across the picture surface, filling the lighter vacant space ahead. The diagonal curve of the horse's neck and sharp line of Lady Lade's whip are echoed in the complex network of branches above, which are silhouetted against a carefully observed sky. Whilst the brooding atmosphere of the right-hand side of the composition suggests the struggle between horse and rider, the viewer's attention is drawn to Lady Lade's white stock and thus to the focus of the image. K.B.

17
Laetitia, Lady Lade, 1793
George Stubbs, b. Liverpool 1724,
d. London 1806
Oil on canvas, 102.2 × 127.9 cm
Signed and dated: *Geo: Stubbs pinxit/1793*

LITERATURE
Millar 1969, no. 1112

EXHIBITIONS
London, Tate Gallery, 1984, no. 134
Cardiff, National Museum of
 Wales, 1990–1, no. 47

THOMAS GAINSBOROUGH (1727–1788)

Diana and Actaeon

This is the only known mythological painting by Gainsborough and was painted c. 1784–6, in the last decade of his life, when he was experimenting with new subject-matter. The story was well known from Ovid's *Metamorphoses*: while out hunting, Actaeon inadvertently comes across the goddess Diana and her nymphs bathing. Diana, angry at the intrusion, splashes water onto Actaeon's face, whereupon he turns into a stag and is torn to death by his own dogs.

The subject of Diana and Actaeon was unusual in British art, but it was a popular subject in the sixteenth and seventeenth centuries, particularly in Italy, and Gainsborough would have been able to see Italian versions in the collections of wealthy patrons or reproduced as prints. His composition has much in common with Filippo Lauri's *Diana and Actaeon*, made accessible by an engraving of 1764. Identifiable models are sculptural. The seated bather below Actaeon is based on a seated woman by Adriaen de Vries. The nymph on the far right is derived from the sculpture known as *Cleopatra* (Rome, Vatican Museums), also used by Reynolds for *The Death of Dido* (see p. 58).

Three preparatory drawings exist which provide detailed evidence of Gainsborough working towards the version in oil and show how stylistically close his paintings and drawings were in the 1780s. He shifts the mood of the story from confusion at the intrusion of Actaeon to a lyrical vision of beauty. Compared with the drawings, the painted composition is clarified, bathers are reduced in number and grouped in pairs – just as Diana, framed by her followers and the large tree behind, confronts Actaeon. Rather than recoiling in fear, he kneels, arms crossed in a protective gesture, like the supplicant pose of Christ in a Baptism. Diana's gesture of calmly offering the water rather than flinging it in anger completes the idyllic mood. The touches of red recall Titian's famous paintings of the story, but the effect is that of contemporary French art.

At first sight the picture looks unfinished, but the brushwork does not suggest it would be taken further and the thick white highlights for the waterfall were added as finishing touches. Crucial areas of the painting, such as Diana and the nymphs about her, are brought to a delicate finish, the moon on Diana's head matching Actaeon's incipient horns. At the correct viewing distance the scene resolves itself into a cool, watery and overgrown grotto. The exposed ground layer covered by transparent glazes unifies the composition and suggests sky, water and glistening flesh. Landscape and figures are fully integrated, as they are in portraits of this date. *Diana and Actaeon* was possibly a private undertaking that was never exhibited. It was acquired by George IV at the artist's posthumous sale at Christie's in 1797 for only £2. 3s. 0d. L.W.

18
Diana and Actaeon
Thomas Gainsborough, b. Sudbury 1727, d. London 1788
Oil on canvas, 158.1 × 188 cm

LITERATURE
Millar 1969, no. 806
Hayes 1970, nos 810–12
Paulson 1975, p. 224
Hayes 1982, I, p. 174, II, no. 160
Bermingham 1987, pp. 46, 207
Cormack 1991, no. 62
Rosenthal 1992, pp. 164–94
Kalinsky 1995, no. 47
Sotheby's 1996, no. 101

EXHIBITIONS
London, Tate Gallery, 1980–1, no. 137
Washington, National Gallery of Art, 1983, p. 150, no. 66
London, The Queen's Gallery, 1994, no. 15

JOHAN ZOFFANY (1733–1810)

John Cuff and his Assistant

Eighteenth-century London developed as the centre of inventions and of the manufacture of scientific instruments. John Cuff (1708–72), Master of the Spectacle Makers Company 1748–9, designed the microscope with the single vertical pillar in 1743, a design that continued to be made well into the nineteenth century. He provided examples for George III and Queen Charlotte, who shared the current enthusiasm for scientific research and technological inventions. Although shown here as an optician, Cuff is known to have sold a wide variety of scientific instruments 'at the sign of the Reflecting Microscope, against Serjeants' Inn Gate in Fleet Street' 1737–57, and at another location in Fleet Street in 1757–8. A note in an inventory drawn up in George III's reign and the painting's entry in the British Institution exhibition of 1814 identify the sitter as John Cuff. This has been disputed, mainly because Cuff was declared bankrupt in 1750 (although he continued to trade). Payments, however, were made on behalf of the King in 1770 and 1771, just before the date of this portrait and Cuff's death in 1772.

Shortly after his move from Germany in 1760, Zoffany's career was secured by the actor David Garrick's commissions of theatrical scenes and by the convention of conversation pieces, in which Zoffany combined accurate and lively portraits of his sitters with signs of their taste or wealth. It was the patronage of George III and Queen Charlotte that made Zoffany fashionable as well as successful.

The idea of showing the sitter not surrounded by his inventions, but informally, in working clothes at his bench is unusual for this date and suggests that the painting may have been commissioned by George III. Horace Walpole criticised it: 'Extremely natural, but the characters too common nature and the chiaroscuro destroyed by his servility in imitating the reflexions of the glasses.' It is precisely this technically brilliant handling of paint, the meticulous recording of the scene like a Dutch or Netherlandish painting and the vivid portraits that make the painting so extraordinary.

As in his conversation pieces in which Zoffany gathered together and recorded his sitter's treasured possessions, here he has constructed a setting to give the illusion of reality, extending the canvas at the lower edge to give the figures more space. Light from the window focuses attention on the sitters, who are like actors on a stage set in one of Zoffany's theatrical pieces. The artificial structure is combined with apparent objectivity in the high finish and precise painting of each detail. With the immediacy of a theatrical painting, Zoffany gives a witty touch as Cuff, in contrast to his serious assistant, pauses in his work to glance up with a slight smile, his spectacles, the mark of his profession, balanced precariously on his forehead. L.W.

19
John Cuff and his Assistant
Johan Zoffany, b. near Frankfurt am Main 1733, d. London 1810
Oil on canvas, 89.8 × 70 cm
Signed and dated: *Zoffanÿ pinx/ 1772*

LITERATURE
Millar 1969, no. 1209
Goodison 1969, pp. 124–5
Johnson 1986, pp. 65–6
Clifton 1995, p. 73

EXHIBITIONS
London, National Portrait Gallery, 1976, no. 71
London, Museum of London, 1987, pp. 111, 266
London, The Queen's Gallery, 1988–9, no. 33
Wellington, Museum of New Zealand Te Papa Tongarewa, 1994–5, no. 24

NATHANIEL DANCE (1735–1811)

Timon of Athens

Nathaniel Dance began his artistic training in about 1748 in the studio of Francis Hayman, an artist best known for his intimate conversation pieces. However, Dance left England in 1754 in order to visit Rome, where he stayed until 1765.

Few paintings survive from Dance's period abroad but the evidence from letters and drawings is that he was one of the first English artists to understand the neo-classical style derived from antique sculpture and decoration. Although principally employed as a portraitist painting Grand Tourists, Dance tried to make his reputation as a history painter, depicting subjects that had a moral and educational theme. One of the founder members of the Royal Academy, Dance resigned in 1790 and became a Member of Parliament. He was created a baronet in 1800.

This painting was probably made around the time of Dance's departure from Rome. Its subject is taken from an episode in the story of the historical figure Timon, a notorious misanthrope. Disgusted at the miserly attitude of his friends, he withdrew from Athens. However, while digging for food he discovered a hoard of gold. The scene in Dance's painting represents the moment when Timon gives away the gold, which he sees as the root of all evil.

Remarkable for both its classical subject-matter and its style, the picture's primary colouring, frozen gestures and frieze-like quality are characteristic features of neo-classicism, which was to be highly influential in European painting during the last decades of the century. It is also a rare example of history painting within the Royal Collection. Possibly the result of a commission from George III to Dance while he was still living in Italy, *Timon of Athens* hung in the King's library at Buckingham House in London.

It has been suggested that Dance is here alluding to his romantic attachment to the German artist Angelica Kauffman, whom he had met in Rome. The image of Timon hurling gold coins could refer to the unhappy outcome of that affair. However, it seems more likely that there might be a connection with the unsuccessful staging of a new play based on Timon's life, adapted from the seventeenth-century plays about him by Shakespeare and Thomas Shadwell. The play was produced and written by James Love (the stage name of Nathaniel's brother) in the summer of 1768, only a few months after Dance's painting was exhibited at the Society of Artists. Timon was repeatedly portrayed in eighteenth-century book illustrations as a practitioner of conspicuous consumption and was invoked as such by Alexander Pope in his fourth Moral Essay, *On the Use of Riches.* K.B.

20
*Timon of Athens, c.*1765
Nathaniel Dance, b. London 1735,
d. Winchester 1811, later
Sir Nathaniel Dance-Holland
Oil on canvas, 122.2 × 137.5 cm

LITERATURE
Millar 1963, no. 725
James 1966, pp. 874–8
Altick 1985, pp. 319–20

EXHIBITION
London, Kenwood House, 1977,
no. 16

BENJAMIN WEST (1728–1820)

The Departure of Regulus

One of a pair of paintings commissioned by George III from West for £420, each of which hung in the Warm Room in Buckingham House. The King had been shown West's *Agrippina Landing with the Ashes of Germanicus* (New Haven, Connecticut, Yale University Art Gallery), painted in 1766 for Archbishop Drummond, and admired it, suggesting to West 'another noble Roman subject … I mean the final departure of Regulus from Rome … you shall paint it for me … come with the sketch as soon as possible'. The picture was included in the first exhibition at the Royal Academy in 1769 (no. 10) at the King's explicit wish.

Having arrived in England from Italy in 1763, West quickly gained the patronage of George III, for whom he became Historical Painter in 1772. West's career reached its climax in 1792 with his election as President of the Royal Academy, in succession to Sir Joshua Reynolds (see p. 58).

Marcus Regulus was a Roman consul (*c.* 300 BC) taken captive by the Carthaginians but promised his release if he negotiated peace or the return of Carthaginian prisoners. Sent to Rome on the condition that he would return if his proposals were not accepted, he persuaded the Senate to decline the terms as dishonourable. He then refused to remain in Rome and returned to Carthage and certain death. West's picture shows him about to depart, spurning the appeals of the Romans who kneel around him and turning his back on his wife Marcia and their children.

Regulus's integrity was celebrated by ancient writers, including Cicero and Horace. Late eighteenth-century European thinkers promoted such ideal historical subjects as it was believed that their emulation would have an ennobling and educational effect. Similarly, artists and writers began to depict subjects taken from Republican Rome, whose ideals were promoted by thinkers behind the American Revolution. The picture also anticipates Republican themes painted over twenty years later by Jacques-Louis David on the eve of the French Revolution, notably *The Lictors Returning to Brutus the Bodies of his Sons* (Paris, Louvre).

Regulus's neo-classical style and composition refer to works by Raphael that West would have known, such as the Vatican Stanze and tapestry cartoons in the King's own collection. The 'scene' is set in the portico of the Roman Senate with an 'audience' framing the foreground. A series of highlighted groups occupy the central stage and a detailed panorama acts as a backdrop. The main procession is both reversing and expanding, creating a dynamic formula which focuses on the central group of Regulus detaining and pacifying the crowd and the seated figures of his wife and children in the far left corner. The Carthaginian group walking away leads the eye through the narrative and the composition. K.B.

21
The Departure of Regulus, 1769
(see also p. 8)
Benjamin West, b. Pennsylvania
1728, d. London 1820
Oil on canvas, 229.9 × 304.8 cm
Signed and dated: BENJAMIN
WEST/PINXIT/LONDINI 1769

LITERATURE
Millar 1969, no. 1152
Uhry Adams 1985, pp. 146–53
Von Effra and Staley 1986, no. 10

EXHIBITION
Baltimore, Baltimore Museum of
 Art, 1989, no. 12

JOHN HOPPNER (1758?–1810)

Mrs Jordan as the Comic Muse

Exhibited at the Royal Academy in 1786 (no. 163) as *Mrs Jordan in the character of the Comic Muse, supported by Euphrosyne, who represses the advances of a satyr,* this picture was important for Hoppner, who was attempting to establish his reputation as a leading portraitist. He had been recommended to George III when young, but his early success at court ended when he quarrelled with his patron. However, he then became the Prince of Wales's Principal Painter in 1793, working for him until 1807.

This painting announced Hoppner's aspiration to be the artistic heir of Sir Joshua Reynolds as it is a conscious emulation of the latter's famous work, *Mrs Siddons as the Tragic Muse* (San Marino, California, The Huntington Library). Just as Mrs Siddons is accompanied by the figures of Pity and Terror, Mrs Jordan has two attendants – Euphrosyne, one of the Graces, a personification of comedy; and a satyr. Both George Romney and Sir William Beechey also painted Mrs Jordan, taking advantage of the new vogue for pictures of actresses, as exemplified by Lawrence's portrait *Elizabeth Farren* (New York, Metropolitan Museum).

Born Dorothea Bland in 1761, Mrs Jordan made her first appearance in London at Drury Lane in 1785 in Richard Sheridan's *The Country Girl,* soon becoming the leading comic actress of her generation. She became the mistress of the Duke of Clarence, later William IV, in 1790, living with him for twenty years and bearing him ten children. However, William was eventually persuaded to leave her in favour of a suitable bride and Mrs Jordan died alone in France in 1815. The present picture was probably purchased by the Duke when William IV; he became anxious 'to have all the pictures of Mrs Jordan, knowing and therefore admiring her public and private excellent qualities'.

The picture was painted during Mrs Jordan's early London career when 'Jordan-mania' had taken hold. The critic Elizabeth Inchbold wrote, 'She came to town with no report in her favour. But ... she at once displayed such consumate [sic] art with such bewitching nature, such excellent sense, and such innocent simplicity, that her audiences were boundless in their plaudits.'

Although Euphrosyne's presence is explained in the title, the satyr's role is not as clear and he could be perceived as an allegory of the male theatregoer. However, if the model for Euphrosyne is Mrs Hoppner, as has been suggested, there may be more personal allusions in this composition, referring to the close relationship between artist and subject – Mrs Jordan was often 'at Hoppner's to whom she sat ... as being esteemed the greatest comic actress of the day'. The brilliant colours and swirling fabrics in the painting are particularly appropriate to such a theatrical sitter, whose obvious charms are ostentatiously displayed.

K.B.

22
Mrs Jordan as the Comic Muse, 1786
John Hoppner, b. London 1758?,
d. London 1810
Oil on canvas, 238.1 × 146 cm

LITERATURE
McKay and Roberts 1909, p. 140
Millar 1969, no. 844

EXHIBITION
London, Kenwood House, 1995,
no. 1

SIR THOMAS LAWRENCE (1769–1830)

Caroline, Princess of Wales, and Princess Charlotte

Caroline, Princess of Wales, married the future George IV in 1795 but within a year the couple had separated and by 1800, when this portrait was begun, she had set up an alternative court at Montague House, Blackheath. Princess Caroline had taken lessons on the harp, an instrument highly regarded in court circles, and here – watched over by a shadowy bust of Minerva, patroness of the arts – she tunes her harp and prepares to play the music offered up by her daughter Princess Charlotte.

Lawrence received the commission from Anne, Marchioness Townshend, Mistress of the Robes to the Princess, through his good friend John Julius Angerstein, a neighbour of the Princess at Blackheath. The painting was subsequently in the 1822 sale of Queen Caroline's possessions. In 1806 the conduct of artist and sitter while it was being painted was scrutinised during the Delicate Investigation. A commission of Cabinet ministers assessed the allegations that the Princess had had an adulterous affair with, amongst others, Lawrence. The Princess stated that Lawrence 'stayed a few nights, that by early rising, he might begin painting on the picture before the Princess Charlotte (who as her residence was at that time at Shooter's Hill, was enabled to come early) or myself came to sit'.

The acrimonious relationship between the Prince and Princess dominated the Regency period, when society was led by the Prince of Wales and captured in the fashionable portraits by Lawrence with their vivid colouring and sensuous handling of paint, which give dazzling surface effects. Typical of Lawrence is the dramatic juxtaposition of the figures against a distant landscape framed by a curtain and arch. Our low viewpoint together with the dominant vertical shape of the harp accentuate the height and therefore the elegance of the Princess. As in other large-scale portraits of this period, mother and daughter are spot-lit as in a theatre against the stormy sky to give a powerful romantic effect; strategic touches of red set off the imposing dark colours. Against this contrived setting is the engaging warmth between mother and daughter. They are caught in mid-action: Princess Charlotte's pose disrupts the stability of her mother's, her right shoe jutting out from the painting, its ribbon undone.

In a preparatory drawing (private collection) Princess Caroline unpacks her harp, her pose reversed and without her daughter. The many pentimenti show Lawrence re-working his ideas on the canvas, possibly from this starting point. He may have extended the canvas on the right in order to accommodate the young Princess.

L.W.

23
Caroline, Princess of Wales, and Princess Charlotte
Sir Thomas Lawrence, b. Bristol 1769, d. London 1830
Oil on canvas, 302.2 × 203.2 cm

LITERATURE
Millar 1969, no. 874
Garlick 1989, pp. 19–22, 165
Fraser 1996, pp. 127–8, 164, 177–8

JAMES WARD (1769–1859)

Nonpareil

One of the most significant sporting artists of the generation following George Stubbs (see p. 64), James Ward trained as an engraver, turning to painting in the later 1780s, having been encouraged by his brother-in-law, the artist George Morland. An intensely ambitious artist, he was the animal painter most closely caught up with the artistic ideals of the Romantic movement. His best paintings are forceful and imaginative, attempting a combination of the portrayal of physical energy with an emotional response to stress and excitement.

In 1794 Ward was appointed Painter and Engraver in Mezzotint to George, Prince of Wales, the future George IV, who purchased this work and its pair, *Monitor* (Royal Collection), from the artist in 1825 for £105 each. Ward became well known as a painter of animals, particularly cattle, during the 1790s, and in 1800 he was commissioned by the Agricultural Society to paint a series of 200 pictures illustrating typical British breeds of livestock. Ward was a prolific artist, painting history pieces and landscapes, such as the enormous *Gordale Scar* (London, Tate Gallery), as well as commissions of portraits of bloodstock. He became a member of the Royal Academy in 1811 and in 1815 won the 1,000-guinea prize at the British Institution for his sketch *The Triumph of the Duke of Wellington* (London, Chelsea Royal Hospital). In the 1820s his income began to decline, and by 1847 he was obliged to apply to the Royal Academy for financial assistance, which was granted in the form of a pension.

Nonpareil, the favourite charger of his most gracious Majesty King George the Fourth was exhibited at the Royal Academy in 1825 (no. 10) and the artist published an engraving of the painting in April 1824. George IV's passion for horse-racing and hunting was well known and his stable legendary. He commissioned portraits of his favourite horses from most of the leading sporting artists of the day, including George Stubbs and Ben Marshall.

This picture is remarkable for its combination of precision in the careful articulation of muscles, the intensity of expression in the horse's head and the fantastic landscape background, which includes a detailed rendition of Windsor Castle from the north-west. The Flemish influence in British sporting painting can be detected from its beginnings down into the nineteenth century and the brushwork in the landscape background of this painting clearly reveals Ward's particular admiration for the technique of Sir Peter Paul Rubens and David Teniers. The luminous rainbow across the back of the composition appears almost as a halo over the horse, endowing it with a spirituality that is characteristic of Ward's best work. It is also evidence of the increasing fascination with the depiction of scientific and meteorological phenomena that gripped artists during the first part of the nineteenth century. K.B.

24
Nonpareil, 1824
James Ward, b. London 1769,
d. Cheshunt 1859
Oil on panel, 80.2 × 111.4 cm
Signed and dated: *J WARD* (in margin) *RA. 1824*

LITERATURE
Millar 1969, no. 1136
Fussell 1974, pp. 65–82

EXHIBITION
London, Hayward Gallery, 1974,
pp. 7–27, 89–91

GEORGE SANDERS (1774–1846)

George Gordon, Sixth Lord Byron

Begun in about 1807, this portrait anticipates Byron's future as a revolutionary figure and through engravings it became the most influential image of the hero of the Romantic movement. George Sanders painted miniatures and life-size portraits in a successful studio in Vigo Lane, London, having arrived from Edinburgh in 1805. Byron commented that one of the two miniatures Sanders painted at about the same time was 'the best miniature of me'. The use of finely woven canvas, the careful finish and attention to detail derive from Sanders's skill as a miniaturist.

The portrait may have been commissioned to commemorate a particular journey. At this period Byron considered various voyages, one of which was a trip in 1807 to the Highlands and Islands and possibly Iceland, before he left for the continent in July 1809. Sanders seems, however, to have managed to reflect the general idea of leaving for a life in exile brought about by Byron's character and work. The water between craggy hills resembles the Scottish landscape and Byron describes the free-born soul 'Which loves the mountain's craggyside, And seeks the rocks where billows roll' in *Hours of Idleness*, published in June 1807. Byron's suit recalls the naval uniforms worn at the recent Battle of Trafalgar and therefore the heroic wars of his time but the fine blue and white silk would have been impractical for a sea voyage. The loosely knotted scarf and open-necked shirt imply rebellion from the starched linen high cravats of accepted fashion. An armed cutter of the naval or revenue service, a type of boat also used by smugglers, flies the Red Ensign in the middle distance. Resolve in the face of a future in exile is implied by the massive hill behind Byron and his right hand spot-lit on the rock, while his other hand, poised against the sail of the ship, is about to give the signal to depart. The scene prophesies Byron's many sea voyages, including his final fatal journey to Greece.

There is circumstantial evidence that the youth who looks up respectfully at Byron is Robert Rushton, the son of a tenant farmer at Newstead, who entered Byron's service in 1808 and to whom Byron was emotionally attached. Rushton accompanied Byron as far as Gibraltar and was the model for the page in *Childe Harold's Pilgrimage*. Byron intended the portrait to be given to his mother. He paid for it to be framed on 18th December 1809 but Sanders retained it in his studio until October 1810, when his mother reported to Byron that 'the countenance is *angelic* and the finest I ever saw and it is very like'. The wide circulation of the engraved versions of Sanders's painting meant that it became the quintessential 'Byronic' image. L.W.

25
George Gordon, Sixth Lord Byron
George Sanders, b. Kinghorn 1774,
d. London 1846
Oil on canvas, 112.5 × 89.4 cm

LITERATURE
Millar 1969, no. 1056
Peach 1993, pp. 285–95
Beevers 1997, pp. 37–42

EXHIBITIONS
London, Victoria and Albert
 Museum, 1974, A41
London, Tate Gallery, 1992, p. 74

SIR DAVID WILKIE (1785–1841)

I Pifferari

In 1825 Wilkie's health broke down as a result of the stresses of his successful career and the death of his mother, two brothers and his sister's fiancé. He travelled throughout Europe for three years to study art and recuperate. In a letter from Rome dated 27th April 1827 to his brother he mentions that he had begun to paint again and had completed two small pictures, one of which was *I Pifferari* (The Pipers) 'little by little' and 'three half hours a day'.

The son of a minister of the Kirk, Wilkie as a Protestant had been much struck by the enthusiasm of Roman Catholics for the rituals of the Church, particularly during the Holy Week of the Jubilee Year 1825: 'Multitudes of pilgrims from all parts of Italy are assembled in the streets, in costumes remarkably fine and poetical ... Each party of pilgrims is accompanied by one whose duty it is to give music to the rest. This is a piper, or pifferaro, provided with an immense bagpipe, of a rich dark tone, the drones of which he has the power of modulating with notes by his fingers, while another man plays on a smaller reed ... In parading the streets they stop before an image of the Virgin, whom they serenade, as shepherds, at this season, previous to Christmas, in imitation of the shepherds of the old, who announced the birth of the Messiah.' (Letter to his brother, 28th November 1825.)

Until then the success of Wilkie's genre and history paintings had depended on the way in which he traced the emotions and character of each participant in a particular situation by the finest nuances of expression and pose. Here the handling of paint is more fluent, the brushwork broader and less detailed. The technique and colour of the paint recall artists of the Venetian School. While in Rome Wilkie studied the frescoes of Raphael in the Stanze in the Vatican. Both this painting and its companion, *A Roman Princess Washing the Feet of Pilgrims* (p. 84), show their influence in the careful construction of space and the setting of stone steps and arches against open sky. It is a copy of Raphael's famous *Madonna della Sedia* (Florence, Pitti Palace) that the pilgrims here are worshipping.

One of Wilkie's predecessors was the Scottish artist David Allan, who some fifty years earlier had drawn and made prints of pilgrims, including *pifferari*, when visiting Rome. Inspired by Scottish vernacular literature, both artists were interested in popular music and musicians as subject-matter. Wilkie aimed for a clear and simple style with a breadth of appeal to the ordinary viewer. Painting, like music, had primitive origins and both are combined in this depiction of a religious ritual being continued from a remote past. L.W.

26
I Pifferari
Sir David Wilkie, b. Cults, Fife
1785, d. off Malta and buried off
Gibraltar 1841
Oil on canvas, 46 × 36.2 cm
Signed and dated: *D. Wilkie Roma/*
1827

LITERATURE
Cunningham 1843, II, p. 194
Millar 1969, no. 1177

EXHIBITIONS
Edinburgh, National Gallery of
 Scotland, 1985, pp. 79–82
Edinburgh, The Talbot Rice Centre,
 The University of Edinburgh,
 and London, Tate Gallery, 1986,
 pp. 64–6, 156–86
Raleigh, North Carolina Museum
 of Art, 1987, pp. 32–4; no. 27

SIR DAVID WILKIE (1785–1841)

A Roman Princess Washing the Feet of Pilgrims

Wilkie had been impressed not only by the devotion of the multitude of pilgrims in Rome in 1825 in the Holy Week for the Jubilee Year, but also by the fact that even the most powerful were humbled and took part in the rituals of the Roman Catholic Church. Wilkie described to his sister the entertainment of pilgrims for three nights at the Convent of Santa Trinità 'with the previous washing of feet' which he had seen performed by 'clerical dignitaries and even princes'. The event inspired the painting *Cardinals, Priests and Roman Citizens Washing the Pilgrims' Feet* (Glasgow Art Gallery and Museum) and this smaller painting of the washing and entertaining of female pilgrims 'rendered unto them by a sisterhood composed of the first ladies of rank and princesses of the place'. Wilkie painted this scene in Geneva in 1827, when he describes it to his brother (12th September 1827): 'a handsome young lady, humbling herself, even to the washing of the feet of a poor pilgrim. What is fortunate – the lady is a favourite figure. Its progress has made a considerable sensation. A young lady I saw by accident that resembled Princess Doria (the person intended) struck me as a perfect model. Interest was made to get her to sit: jewels and plate were borrowed and every assistance procured for me that I could possibly want.' A preparatory drawing is in the Musée Magnin, Dijon.

Although painted a few months after *I Pifferari* (see p. 82), this internal scene complements the external one, with architecture and steps to the left and a kneeling woman in the centre. The clarity of the composition with only a few figures again reflects the influence of Raphael's frescoes in the Vatican Stanze. Wilkie wrote that in oil painting richness and depth alone can do justice to the material. He praises Titian for his depth of colouring and Raphael for the tone of the light and depth of shadow. In this painting the eye moves from figures in the foreground in full light to those in half-shadow and deep shadow, where bitumen was applied to create the richness of Old Masters. Dutch seventeenth-century artists, particularly Rembrandt – as well as the Venetians, such as Veronese and Titian – inspired the fluid use of oil and the attention to narrative details, the rosary laid under the bench and the ewer and basin on the floor.

In 1828 George IV supported Wilkie at the crucial moment in his career when he returned to London after three years' absence, his health still precarious, his new work in a broader, darker and more painterly style. The King's purchase of these two Italian pictures and an entire series of Spanish paintings confirmed Wilkie's reputation in the eyes of the British public. L.W.

27
A Roman Princess Washing the Feet of Pilgrims
Sir David Wilkie, b. Cults, Fife 1785, d. off Malta and buried off Gibraltar 1841
Oil on canvas, 50.2 × 42.2 cm
Signed and dated: *David Wilkie Geneva 1827*

LITERATURE
Cunningham 1843, II, pp. 175, 454
Millar 1969, no. 1178

EXHIBITIONS
Edinburgh, National Gallery of
 Scotland, 1985, pp. 79–82
Edinburgh, The Talbot Rice Centre,
 The University of Edinburgh,
 and London, Tate Gallery, 1986,
 pp. 64–6, 156–86
Raleigh, North Carolina Museum
 of Art, 1987, pp. 32–4; no. 28

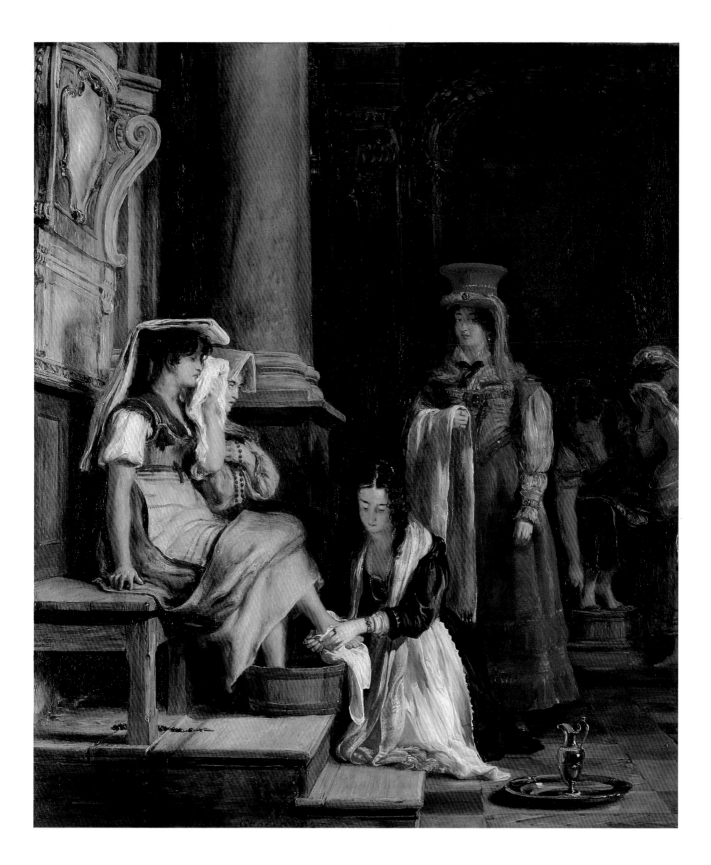

SIR DAVID WILKIE (1785–1841)

Abd-ul-Mejíd

In 1840 Wilkie arrived in Constantinople, where he stayed for three months before journeying on to the Holy Land. He was granted permission to paint the Grand Sultan, Abd-ul-Mejíd, as a present for Queen Victoria.

The first sitting in the Sultan's Winter Palace on 12th December and the subsequent four sittings are vividly recorded in Wilkie's journal and letters, and the process of composition can be discerned in the layers of paint on the panel. Wilkie began with the head, which has tighter modelling than the rest of the portrait, and suggested the Sultan be shown sitting on a throne receiving people. In the second sitting, the Sultan suggested that he should wear white gloves and sit on a sofa. In the third sitting Wilkie raised the sword and hands higher in the picture, painted in the diamond hilt of the sword and resumed work on the head. 'His Highness was most particular about the likeness, which, in the course of sitting, I had to alter variously, the Sultan taking sometimes the brush with colours, and indicating the alteration he wished made.' On 27th December, after an 'excellent sitting of two hours', the Sultan requested a copy, which Wilkie agreed to begin in Constantinople and finish in London. At the final sitting on 3rd January when he worked on the copy ('I thought it became more like than the first'), the Sultan gave him a gold snuff box as a sign of his esteem. The two portraits were sent in separate shipments for London before Wilkie's departure. This portrait was exhibited at the Royal Academy in 1842 and the copy must be the version now in the Topkapi Museum in Istanbul. Wilkie died at sea in 1841 on his return voyage from the east.

Wilkie's travels were driven by a search for authenticity for his religious paintings and a fascination for the picturesque. He hoped the warmer climate and travel would help his fragile health. In addition Queen Victoria, unlike George IV, was unhappy with his formal portraits as Painter in Ordinary. Wilkie himself disliked the scale and demands of such commissions, smaller portraits suiting his style better. This painting has some of the delicacy of a watercolour. Much careful pencil drawing outlining details, such as the pattern of the sofa, is still visible under transparent layers of paint, contrasting with thick fluid touches like the carving of the sofa. Wilkie had a good relationship with the Sultan, describing him as having 'good eyes and mouth, about eighteen years old and marked by small pox'. The sympathy between artist and sitter is perceptible in the face, which is vividly set off by Wilkie's curiosity and enthusiasm for the exotic costume of his subject in what he described as 'this strange, passing strange land'.

L.W.

28
Abd-ul-Mejíd (1823–1861),
Sultan of Turkey
Sir David Wilkie, b. Cults, Fife
1785, d. off Malta and buried off
Gibraltar 1841
Oil on panel, 70.2 × 58.7 cm

LITERATURE
Cunningham 1843, III, pp. 327–8,
 345–52, 354–5, 358–63
Millar 1969, no. 1190

EXHIBITIONS
Edinburgh, National Gallery of
 Scotland, 1985, pp. 83–94
Oxford, Ashmolean Museum,
 1985, no. 63
Raleigh, North Carolina Museum of
 Art, 1987, pp. 44–5, nos 46, 63

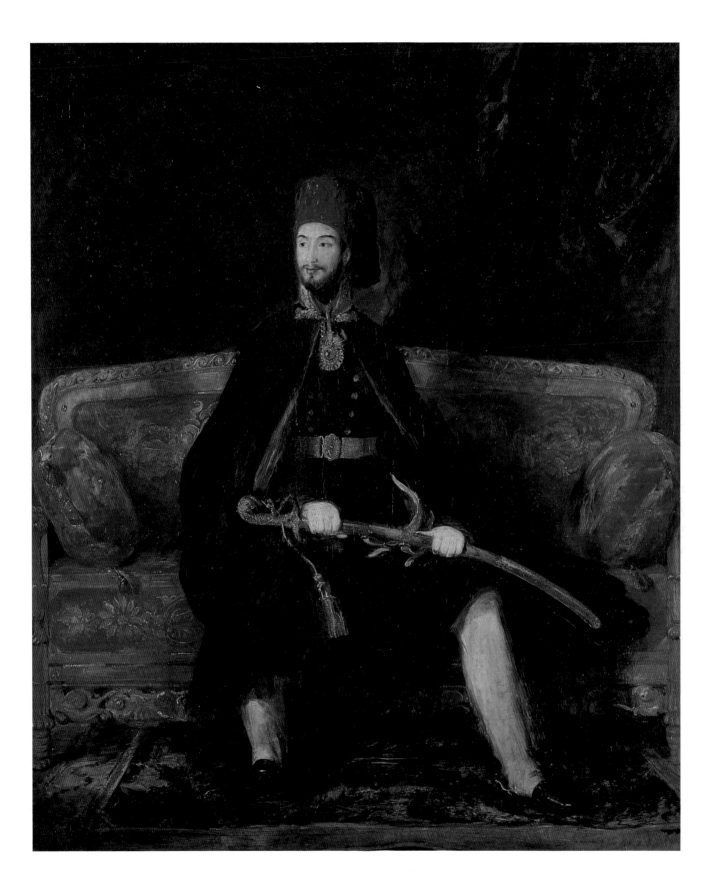

BENJAMIN ROBERT HAYDON (1786–1846)

The Mock Election

The subject-matter of this painting derives from an incident at the King's Bench Prison, where the artist was serving his second sentence for debt, during the summer of 1827. He records that he had seen a 'masquerade election ... Rabelais or Cervantes alone could do it justice ... Never was such an exquisite burlesque. Baronets and bankers, authors and merchants, young fellows of fashion and elegance, insanity, idiotism, poverty and bitter affliction, all for a moment forgetting their sorrows and the humour, the wit, the absurdity of what was before them ... I thought it the finest subject for humour and pathos on earth.' The inmates formed a procession, headed by self-appointed officials, in order to open a poll for the election of a member to plead for their parliamentary rights. The two candidates – both in fantastic costume – one raising his fist, the other waving his hat, are placed in the centre of the upper tier of the crowd.

After his release, Haydon returned to the prison to take the portraits of those involved, including the seated figure on the right, whom he describes as having 'one of the most tremendous heads I ever saw ... something between Byron and Bonaparte ... he seemed like a fallen angel, meditating on the absurdities of humanity!' The picture was exhibited at the Egyptian Hall, sent to Kensington Palace on George IV's instructions and subsequently purchased by the King for 500 guineas.

One of Haydon's most successful narrative pictures, *The Mock Election* shows that he was conscious of Hogarth's burlesques (such as *The March to Finchley*, London, Coram Foundation). The picture refers to the contemporary debate on electoral reform and to the suffering of those in debtor's prisons. The picture also expresses Haydon's optimism that 'men, unfortunate and confined, could invent any amusement at which they had a right to be happy'.

Trained at the Royal Academy Schools and a passionate follower of Reynolds's *Discourses*, Haydon described himself as a 'Historical painter'. His great ambitions and talents were not fully realised or appreciated, perhaps because of his egotism and sense of superiority. A critic and brilliant diarist, he was a champion of state support for the arts as well as encouraging fellow artists and writers such as Sir David Wilkie (see pp. 84, 86) and William Wordsworth. Sadly, the King did not buy the companion piece, *Chairing the Member* (Tate Gallery) and the artist was eventually driven to suicide through debt and depression. K.B.

29
The Mock Election, 1827
Benjamin Robert Haydon,
b. Plymouth 1786, d. London 1846
Oil on canvas, 144.8 × 185.4 cm

LITERATURE
Taylor 1853, pp. 179–88
Millar 1969, no. 829

EXHIBITIONS
Essen, Villa Hugel, 1992, no. 404
The Wordsworth Trust, Dove
 Cottage, 1996, nos 115–18

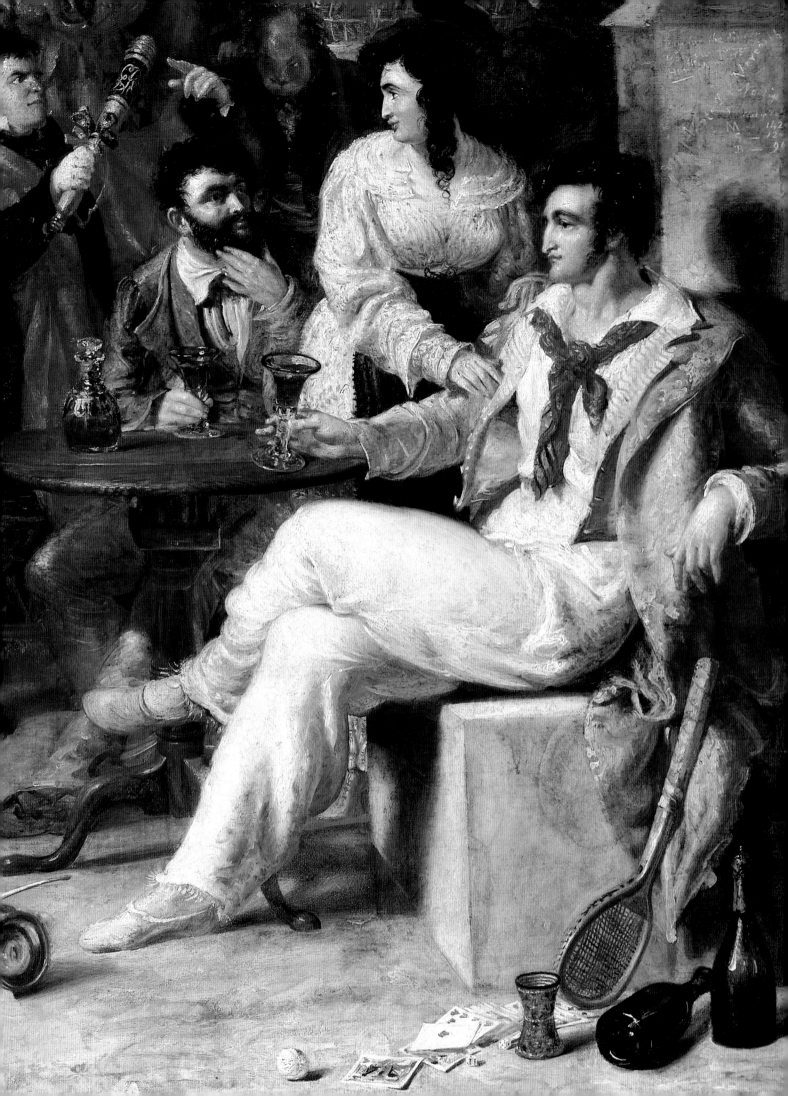

WILLIAM MULREADY (1786–1863)

The Interior of an English Cottage

Mulready turned to narrative subject-matter from local landscape views and exteriors of cottages around London. Dated 1828, this is his most complex and highly detailed treatment of a cottage interior and a rural theme. Silhouetted against a large window, a wife anxiously awaits the return of her husband; her daughter has fallen asleep in her lap, a book in her hand, and her son sleeps in the cradle. Her husband's slippers are being kept warm by the fire, his supper is on the table. In the distance the returning man on horseback raises his hat in greeting against the new hope of a dawn sky. His dog has recognised him but his wife, her face in gloomy shadow, looks back into the dark interior. Mulready uses the distant space to tell us the next stage of the story, still unknown to the main protagonist, a structuring of space he also employed in his printed illustrations of stories and fables. In Mulready's account book the painting is referred to as 'the Game-keeper's wife' but, as with other narrative paintings, he preferred a less specific exhibition title suggesting a more universal, timeless image.

Mulready rigorously researched his paintings and made written notes and drawings. A drawing known as *Interior of a herd's house, Mounces* (1814, British Museum) is a rare record by him of an actual cottage interior. The artist may have used features of observed drawings like this combined with other studies. A finished drawing in chalk of the composition survives (Victoria and Albert Museum), as does a tiny oil sketch (8.2 × 7 cm, Tate Gallery) which established areas of light and shade. At this date Mulready started to use a white ground on which the numerous contents of the cottage's interior are meticulously defined using warm reds and brown and transparent glazes. The technique, with its stippled effect, was later taken up by the Pre-Raphaelites. This exact rendering of each object in the dark interior heightens the realism of the scene, contributing to its sombre mood. Despite the homeliness of the cottage, it has been noted that furniture such as the bulky storage container above the window gives the interior an oppressive feel. The stark transition from this interior to the wide open landscape beyond heightens the sense of drama. The mother takes up the archetypal role of a waiting woman, explored by later Victorian artists, her pose with her daughter reminiscent of an antique sculpture, a Michelangelo or a Raphael model.

It was Mulready's technical skill and his attention to the narrative, like that of the Dutch masters he had studied, that made this painting so appealing to George IV. L.W.

30
The Interior of an English Cottage
William Mulready, b. Ennis,
Co. Clare 1786, d. London 1863
Oil on panel, 62.1 × 50.1 cm
Signed and dated:
William Mulready. 1828.

LITERATURE
Millar 1969, no. 971
Heleniak 1980, pp. 134–5, no. 116

EXHIBITION
London, Victoria and Albert
 Museum, 1986, pp. 167–9

GEORGE CRUIKSHANK (1792–1898)

The Disturber Detected

'The subject ... represented the interior of a country church, where a boy, having accidentally dropped his peg top on the pavement, is attracting the attention of the congregation; among these is the beadle, who gives the convicted culprit, a look; promising him *something*, when service is concluded' is how the subject is described in the unpublished memoirs of the artist's nephew. Cruikshank had originally gained a reputation as one of the most inventive and sharpest caricaturists satirising society and politics in the turbulent era at the beginning of the nineteenth century, and later by imaginative book illustrations. By 1850, his desire for independence from publishers and a shortage of commissions spurred him on to take up oil painting; in 1853, at the age of 61, having supported himself in graphic art for more than forty years, he entered as a student at the Royal Academy to gain technical training.

Cruikshank found the narrative composition difficult to resolve. He also found painting in oil laborious, admitting that he missed the etching tool which gave a 'living sensation to the brush; so different to the fat touch of the oil painter's brush'. Despite his doubts about the medium, *The Disturber Detected* is one of his most successful ventures into oils. Indebted to the anecdotal paintings by Wilkie (see pp. 82–7) and Mulready (p. 90), the picture's treatment is closer to Cruikshank's detailed illustrations than to the financially disastrous large pictures he went on to paint, culminating in the *Worship of Bacchus* (Tate Gallery).

The church interior is imaginary, but the brass is based on that of Sir Roger Trumpington in St Mary and St Michael's Church, Trumpington, Cambridgeshire. Cruikshank's family modelled for some of the participants. His nephew Percy was the beadle with a 'gorgeous gold laced beadle's many-caped coat, stick tow-coloured wig etc.' As well as making preparatory studies (Victoria and Albert Museum, Cleveland Museum of Art), Cruikshank planned parts of the composition on the panel with incisions as if etching on a plate. He then outlined details, particularly in the architecture, in ink, and these frequently form part of the finished effect. Cruikshank's use of finely delineated white highlights and the dramatic effect of light, particularly the extraordinary light thrown up on the beadle's face, recall the strong contrasts of light in his black-and-white etchings. Fine touches of humour are apparent, such as the small statue of St Mark on top of the beadle's rod of office, which mimics the pose of the large pompous figure beneath.

Prince Albert agreed to purchase the painting for £31 10s and it was completed in 1850. The transaction contrasts with the artist's previous receipt of money from royalty; the Prince Regent, at the height of the uproar over Princess Caroline, paid him £100 not to caricature him 'in any immoral situation'. L.W.

31
The Disturber Detected
George Cruikshank, b. London 1792, d. London 1898
Oil on panel, 44.8 × 56 cm
Signed and dated:
GEORGE/CRUIKSHANK/1850

LITERATURE
Millar 1992, no. 219
Patten 1992, 2, pp. 220, 277–9, 289–90, 357

EXHIBITION
London, Museum of the Order of St John, Clerkenwell, 1992, p. 9

SIR EDWIN LANDSEER (1802–1873)

Queen Victoria

The painting of this engaging image of the young Queen in white, aged only 20, was recorded in Queen Victoria's Journal (28th August 1839): 'sat for some little time to Landseer, who has made in three days the likest little sketch in oils of me, that ever was done; en profile, the back seen, in my morning dress, without my tippet, and with my blue ribbon' (the Broad Riband of the Order of the Garter). The portrait retains the spontaneity of a sketch and is so described by the artist in the inscription. It marks the beginning of a long relationship between the monarch and one of the most popular artists of the nineteenth century.

Queen Victoria had admired Landseer's work exhibited at the Royal Academy in 1833. He painted Princess Victoria's dog Dash in 1836 as a birthday present from her mother, the Duchess of Kent, and the following year they met when he brought a sketch of Hector and Dash – 'He is an unassuming, pleasing and very young looking man, with fair hair.' Until the ascendancy of Franz Xaver Winterhalter, Landseer became in effect court painter and throughout his life painted portraits of royal children, pets and family groups. Landseer's sympathy with animals, particularly dogs, and his ability to paint them were admired by the Queen and from 1842 they shared a love of the Highlands. Both she and Prince Albert used to visit Landseer's house; he was, as the writer Heaton commented, 'a privileged friend'. Landseer gave the royal couple instruction in etching and helped the Queen with her drawing. She was well aware of his personal failings, his neuroses exacerbated by alcohol abuse. In 1839 she and Lord Melbourne discussed Landseer's 'idleness and laziness, not coming to Windsor when I said he might paint me ... then never sending in his bill'. Although superb as an animal painter, Landseer often found it difficult to paint a good portrait likeness, particularly of the royal family in important commissions, and to finish paintings on time. On her part the Queen was a demanding patron, 'a very *inconvenient* treasure' (Landseer). Yet, in 1850 she knighted Landseer and in 1867 offered him 'the comforting breezes of Balmoral' to help his ill-health. On learning of his death she mourned him as 'the great artist & kind old friend ... How many an incident do I remember, connected with Landseer!' L.W.

32
Queen Victoria
Sir Edwin Landseer, b. London
1802, d. London 1873
Oil on canvas, 40.6 × 30.5 cm
Signed and dated: *Sketch/E.L. 1839*

LITERATURE
Heaton 1880, III, p. 386
Millar 1992, no. 395

EXHIBITION
Philadelphia, Philadelphia Museum
of Art and London, Tate Gallery,
1981–2, pp. 14–16, 142–65

Sketch
E.L. 1889

SIR EDWIN LANDSEER (1802–1873)

Princess Victoire of Saxe-Coburg-Gotha

Landseer has wittily juxtaposed the back view of Princess Victoire, all in white, with the dark form of her spaniel, who sits beside her on a terrace overlooking a formal garden. The couple appear to commune in silence while studying the view, their attention fixed on the fountain rising from below. The ears of the spaniel correspond to the long ringlets of its mistress and the turn of their heads match, the spaniel's small front left leg copies her left hand, its dark tail echoing her white handkerchief.

Princess Victoire, the daughter of Duke Ferdinand of Saxe-Coburg, was the beloved cousin of Queen Victoria and regarded as a sister. On 10th September 1839 Queen Victoria noted in her Journal that the Baroness Lehzen 'brought in a lovely sketch in oils Landseer has done of Victoire's back, as a surprise for me; it is so like, – such a treasure – just the figure of that Angel'. A year later Princess Victoire married the Duc de Nemours, second son of Louis-Philippe of France. Queen Victoria was much saddened by her sudden death in 1857 after the birth of her second daughter.

The painting has the light touch and fresh application of paint of a quick sketch. The ground of the canvas is barely covered and pencil under-drawing is still visible in areas such as the Princess's white dress. Landseer may have intended the frame to be arched at the top to continue the framing idea of the trees and flowers.

Landseer studied animals from an early age and had a strong emotional response to them, particularly dogs, in whom he invested anthropomorphic qualities. Landseer's ability to record their likenesses delighted the Queen. Here the close bond between the spaniel and its mistress is celebrated by their similarities and their mutual agreement. This light-hearted portrait of 1839 prefigures future glimpses of court life painted by Landseer, showing the private family life of a happily married couple away from ceremonial procedures, surrounded by children and dogs, 'happy and blessed in one's home life'. (Journal, 1846.) L.W.

33
Princess Victoire of Saxe-Coburg-Gotha
Sir Edwin Landseer, b. London 1802, d. London 1873
Oil on canvas, 44.4 × 35.6 cm
Signed and dated: *Sketch/EL. 1839*

LITERATURE
Millar 1992, no. 409

EXHIBITION
Philadelphia, Philadelphia Museum of Art and London, Tate Gallery, 1981–2, p. 150

SIR EDWIN LANDSEER (1802–1873)

Queen Victoria Landing at Loch Muick

Landseer first visited Balmoral in 1850, the year he was knighted, to begin his largest royal commission, 'a beautiful historical exemplification of peaceful times, & of the independent life we lead in the dear Highlands'. The Queen discussed the idea at length, writing in her Journal on 19th September 1850: 'It is to be thus: I, stepping out of the boat at Loch Muich, Albert, in his Highland dress, assisting me out, & I am looking at a stag which he is supposed to have just killed. Bertie is on the deer pony with McDonald (whom Landseer much admires) standing behind, with rifles and plaids on his shoulder.'

Landseer drew detailed studies of the heads of four Highlanders. As Sir Oliver Millar has pointed out, 'The ghillies were made to look like Apostles (Landseer himself likened Macdonald to a Giorgione); the agony in the faces of the dead stags is reminiscent of the heads of Saints being torn apart in the more violent altarpieces of the Counter-Reformation.' It has been suggested that Queen Victoria, the focus of the scene, recalls Mary, Queen of Scots, stepping ashore after her escape from Loch Leven. The way in which Prince Albert turns elegantly against the wild landscape to hand her down, at the same time displaying his prowess in the noble sport of hunting, refers back to an earlier age of romance and chivalry. Landseer had fallen in love with the Highlands eighteen years earlier and every autumn visited friends there to enjoy shooting and painting.

In 1851 this small oil sketch for *Royal Sports on Hill and Loch* was praised by Queen Victoria, 'slight as it is the effect is beautiful', but for the rest of his life Landseer struggled to complete the large version. His failure with 'The Boat Picture' may have caused his fall from royal favour for about a decade and a friend considered that the problems Landseer had with it hastened his death. Good likenesses were troublesome. In 1851 Landseer kept 'washing out what he paints in, so that he gets his faces too weak' (Journal) and Franz Xaver Winterhalter was called in to assist and advise. The unfinished painting was exhibited at the Royal Academy in 1854 and again in 1870, but in the intervening period Landseer had over-worked it, using glass to scrape out the paint. The final appearance of the painting is recorded in an engraving but its sad state led George V to order it to be destroyed.

In its spontaneity the sketch vividly captures the fascination the royal family and the Victorians felt for the Highlands and in 1861 Queen Victoria requested the sketch, 'valuable to her as a remembrance of happy times', back from Landseer. L.W.

34
Queen Victoria Landing at Loch Muick (preparatory sketch for *Royal Sports on Hill and Loch*)
Sir Edwin Landseer, b. London 1802, d. London 1873
Oil on canvas, 42.9 × 76.5 cm

LITERATURE
Millar 1977, p. 173
Millar 1985, pp. 47–52
Millar 1992, no. 402

EXHIBITION
Philadelphia, Philadelphia Museum of Art and London, Tate Gallery, 1981–2, pp. 160–3

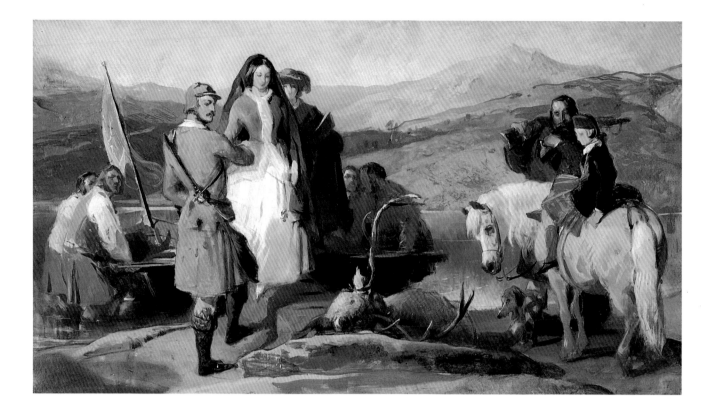

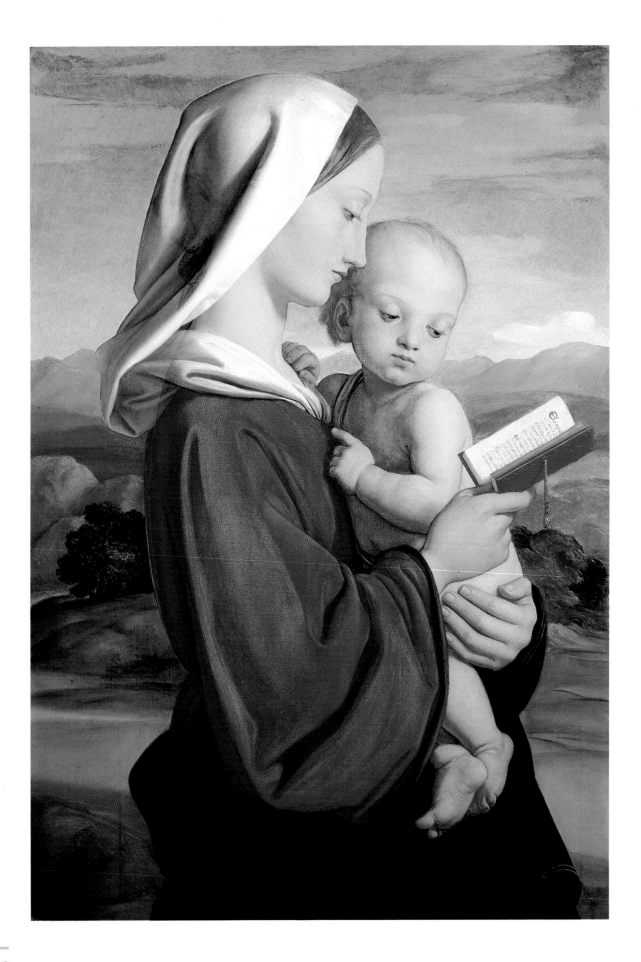

WILLIAM DYCE (1806–1864)

The Virgin and Child

Acquired by Prince Albert in the year it was painted, 1845, this painting was described by Queen Victoria as 'quite like an old Master, & in the style of Raphael – so chaste & exquisitely painted' (Journal, 1845). Dyce shared with Prince Albert a concern for the part art should play in society. The rigorous order of the design and the use of the profile view can be found in other paintings of this date and reflect Dyce's participation in government schemes to apply design to industry.

Another important facet of Dyce's character was his involvement with religious revivalism in England. The simplicity of the design and its reverent mood are part of his search to rekindle the spiritual purity of ancient art in a materialistic age. This aim had much in common with that of the German Nazarenes, who wanted to revive religious and historical art by returning to the principles of the time of Raphael and Albrecht Dürer. Although Dyce probably met artists such as Frederick Overbeck and Julius Schnorr von Carolsfeld during one of his visits to Rome in the 1820s, their influence only becomes markedly apparent in his paintings of the 1840s. Dyce's few surviving paintings of the Virgin and Child are particularly indebted to *The Tempi Madonna* (Munich, Alte Pinakothek), the *Madonna del Granduca* (Florence, Palazzo Pitti) and the large *'Cowper Madonna'* (Washington, National Gallery of Art) – all by Raphael and dating from the early sixteenth century. The Royal Collection's painting is less sensuous and more severe than the *Virgin and Child* of *c.* 1838 by Dyce (Tate Gallery), which presents a tender, maternal image of a mother and child. There is a version in the Castle Museum, Nottingham, which is so close to cat. no. 35 that it may have been a preparatory study for it. In it the Virgin is bareheaded, as she originally was in the Royal Collection's painting. Like those of the Nazarenes, Dyce's paintings have an emphasis on simple poses, purity of outline and flatly applied colours, and lack chiaroscuro. The flat effect of the painting also derives from his investigation at this date into the technique of fresco painting. Prince Albert wanted to encourage a national revival of monumental art and saw fresco decoration as a means of doing this through his patronage of artists such as Dyce, who painted *Neptune Resigning his Empire of the Sea to Britannia* (1847), dominating the main staircase at Osborne House.

L.W.

35
The Virgin and Child
William Dyce, b. Aberdeen 1806,
d. London 1864
Oil on canvas, 80.2 × 58.7 cm
Signed and dated: w D (in
monogram) *1845*

LITERATURE
Pointon 1979, pp. 36–7, 40, 87–9,
197
Vaughan 1979, pp. 199, 238–9
Millar 1992, no. 227

EXHIBITION
London, National Gallery, 1991,
no. 90

DANIEL MACLISE (1806–1870)

A Scene from 'Undine'

This painting illustrates an episode from chapter 9 of the novel *Undine* by the Romantic German writer Friedrich Heinrich Karl, Baron de la Motte Fouqué (1777–1843), first translated into English in 1818. The young knight Huldbrand escorts his bride, Undine, a water spirit, through the forest accompanied by the priest Father Heilmann, who has just married them. Undine's uncle, Kühleborn, a powerful water spirit and her 'terrible protector', attempts to frighten them. Huldbrand strikes him with his sword, but Kühleborn transforms himself into a waterfall. Undine chooses her bridegroom, turning her back on her sister water spirits and her uncle. Here they emerge from the menace of the forest, but the force of elemental nature is more powerful than the mortal world and in the end Kühleborn reclaims Undine. A preparatory study is in the Victoria and Albert Museum.

There was a growing interest in German civilisation in nineteenth-century England, encouraged by Prince Albert. Enthusiasm for German literature encompassed *Undine*, which from the 1840s became almost as popular with artists as Goethe's *Faust* and supplied subject-matter for fairy paintings, popular at that date. These developed from the work of William Blake and Henry Fuseli, but were much influenced by German literature, popularised in the 1840s by the accompanying illustrations. An outstanding example was *Grimm's Fairytales*, published in 1824. Maclise, with his Irish background and interest in Celtic traditions, had already illustrated another influential work on the subject, Croker's *Fairy Legends and Traditions of the South of Ireland* (1826).

Like other fairy painters, Maclise was probably inspired by contemporary ballet and theatre. Some of the imagery for his painting may have been derived from Jules Perrot's ballet *Undine*, performed in London in the year the painting was produced. Maclise was already well known as a leading exponent of 'Germanism', much influenced by the illustrations of Moristz Retzsch (1779–1857). In *Undine* the main protagonists are framed by the oval of teeming, imaginary figures who form an ornamental border like that of a German engraving. The extraordinary attention to detail shows Maclise's skill as an illustrator. The looming figure of Kühleborn provides a telling respite from the crowded scene, an imaginary world as minutely itemised as William Frith's crowded records of the real world (see p. 104).

Queen Victoria purchased *Undine* for 100 guineas as a birthday present for Prince Albert in 1843. Maclise's close friend Charles Dickens wrote to Cornelius Conway Felton: 'He [Maclise] is in great favour with the Queen, and paints secret pictures for her to put upon her husband's table on the morning of his birthday.' L.W.

36
A Scene from 'Undine'
Daniel Maclise, b. Cork 1806, d. London 1870
Oil on panel, 44.2 × 60.9 cm

LITERATURE
Millar 1977, p. 174
Vaughan 1979, pp. 117, 171–3
Millar 1992, no. 486

EXHIBITIONS
London, National Portrait Gallery and Dublin, National Gallery of Ireland, 1972, no. 80
London, National Gallery, 1991, no. 89
London, Royal Academy, 1997–8, pp. 16, 65–6, 88–92

WILLIAM POWELL FRITH (1819–1909)

Ramsgate Sands: 'Life at the Seaside'

In his autobiography Frith records that he spent his summer holiday of 1851 at Ramsgate Sands and that, weary of costume painting, 'I had determined to try my hand on modern life.' After three years' work, this first ambitious scene of contemporary everyday life was exhibited at the Royal Academy in 1854 and was so well received that Frith went on

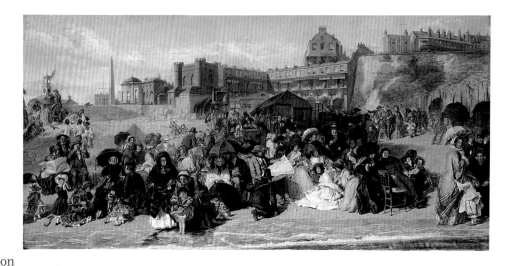

to paint his other major narrative paintings, *Derby Day* (1858, Tate Gallery) and *The Railway Station* (1862, Egham, Surrey, Royal Holloway and Bedford New College).

The development of the railways in the 1840s enabled even poorer members of London's population to enjoy day trips to the sea. Resorts such as Ramsgate were transformed from quiet, dignified towns by the arrival of the crowds depicted by Frith. 'The variety of character on Ramsgate Sands attracted me,' he wrote, 'all sorts and conditions of men and women were there. Pretty groups of ladies were to be found, reading, idling, working and unconsciously forming themselves into very paintable compositions.' Predominantly middle-class families are here forced into close proximity with the less affluent, including tradesmen selling wares and entertainers. Frith was anxious to include accurate portraits of the various characters he had seen and much of 1853 was taken up with searching for suitable models. His painting method was recorded by Maclise, who on a visit to his studio found him 'dropping in here and there gem-like bits into the beautiful mosaic which he had so skilfully put together'. The static crowds in photographs of beach scenes in the 1850s are by comparison uninteresting; their clothes, as Frith noted, are 'unpicturesque'. Watched by the girl paddling and the child with a telescope on the left, our viewpoint from out at sea dramatises Frith's crowd. It is made up of a series of carefully interlocking episodes which we are invited to explore and dwell on in their rich variety. Contemporary reviews show that viewers effectively read Frith's paintings like novels.

Despite contracting typhoid there in 1835, Queen Victoria probably had happy childhood memories of visits to Ramsgate, which broke the lonely routine of the schoolroom. She and Prince Albert bought the painting from the dealers Messrs Lloyd for 1,000 guineas after seeing it in the 1854 Royal Academy exhibition. L.W.

37
Ramsgate Sands: 'Life at the Seaside'
William Powell Frith, b. Aldfield near Ripon 1819, d. London 1909
Oil on canvas, 77 × 155.1 cm

LITERATURE
Frith 1887, I, pp. 243–67
Cowling 1989, pp. 219–31
Millar 1992, no. 242

EXHIBITION
London, National Gallery, 1991, no. 74

FREDERIC, LORD LEIGHTON (1830–1896)

Bianca

Painted in 1862 and acquired *c.* 1865 by Edward VII when Prince of Wales. The artist became a friend of the Prince, who supported his career, having first met him in Rome in 1859. The Prince wrote to Queen Victoria in October 1878 urging that she should 'intimate a strong desire to the Royal Academy that Mr Leighton should be chosen as President ... as he is really the only man in this Country who has a thorough knowledge & appreciation of art'. This advice seems to have been heeded; Leighton was elected President later that year. The royal family's support of Leighton had begun in 1855 at a crucial stage in his early career when Queen Victoria purchased his first Academy exhibition piece, *Cimabue's Madonna Carried in Procession*. She realised the significance of her actions, recording in her Journal, 'Albert was enchanted with it – so much so that he made me buy it. The young man's father, said that his future career in life would depend on the success of this picture.' The painting is at present on permanent view in the entrance hall of the National Gallery in London.

Leighton became one of the most prominent figures in the British art establishment of the second half of the nineteenth century. As President of the Royal Academy he took an interest in exhibitions of Old Masters, establishing new galleries and organising exhibitions. He was created a baronet in 1886 and a peer less than a month before his death. His subject-matter ranged from portraiture and scenes from life in medieval Italy to episodes from classical history and mythology and evocations of the classical past. An accomplished draughtsman, he was a follower of Ruskin's advice to 'go to nature' but was never associated with the Pre-Raphaelite movement, despite sharing some of their ideas.

This image is comparable with other single-figure portraits of women that Leighton executed in the 1860s, such as *Eucharis* (private collection), which shows a young girl of a similar facial type in profile, carrying a basket of fruit on her head. Bianca also appears to have a deliberately ambiguous title which refers to the sitter's name as well as to the idea of feminine purity and innocence. These ideals are conveyed through the model's downcast gaze, white skin and clothing and the doves on the curved wall behind her – which frames her for the viewer but also encloses and restrains her. The painting is without any ostensible subject or narrative implications and the girl's eyes deliberately avoid any communication between artist and spectator. Leighton seems to be seeking to evoke an abstract quality of feminine grace through generalisation as well as through contemporary romantic associations with classical beauty, as suggested by Bianca's Venetian Renaissance costume. K.B.

38
Bianca, 1862
Frederic, Lord Leighton,
b. Scarborough 1830, d. London 1896
Oil on canvas, 59.1 × 51.1 cm

LITERATURE
Millar 1992, no. 453

EXHIBITION
London, Royal Academy, 1996, pp. 127–8

SIR LAWRENCE ALMA-TADEMA (1836–1912)

God Speed

The only oil painting by the Dutch-born artist remaining in the Collection, *God Speed* was painted by Alma-Tadema as a present to the Duke and Duchess of York (later George V and Queen Mary) on their wedding, 6th July 1893. At the memorial exhibition of Alma-Tadema's work in 1913, George V found some of his pictures 'quite beautiful'.

Originally from Friesland, Alma-Tadema studied at the Antwerp Academy and with Henri Leys, Belgium's leading history painter. In 1869 he moved to London, becoming naturalised four years later. He rapidly achieved both artistic and social success with his skilful re-creations of everyday scenes from classical life. Appointed a Royal Academician in 1879, he was knighted twenty years later.

Of a sociable nature, the artist became a friend of the Prince of Wales (later Edward VII), who visited his home, Townshend House, in 1880. Later Alma-Tadema dined with the Prince on 1st March 1893, shortly before his son's wedding. Though *God Speed* was a wedding present to the Duke of York, it can perhaps be better seen as a token of the artist's friendship with the Prince of Wales, the leader of London society. This friendship was cemented by gifts of watercolours from the artist and social recognition from the newly crowned Edward VII and Queen Alexandra. On 17th March 1903 Alma-Tadema was honoured with a visit from the royal family to his home in Grove End Road. There Edward VII was especially impressed by an Egyptian picture in progress, *The Finding of Moses*. In 1904 the King further recognised Alma-Tadema's work by personally awarding him the new Order of Merit.

God Speed belongs to a group of Alma-Tadema's paintings begun in the mid-1880s, depicting Roman women on marble terraces high above the Mediterranean. Some of these pictures incorporate a restricted view of the vertiginous drop to the sea, a perspective device further developed in his well-known *A Coign of Vantage* of 1895. *God Speed* depicts a young Roman woman dropping roses from such a terrace. The maritime setting is probably that of the Bay of Naples, an imperial Roman resort dotted with luxury villas of emperors and wealthy patricians, many spectacularly sited on the cliffside. Alma-Tadema creates an additional interest in his scene by leaving to our imagination the recipient of the roses. It is most likely that he intended a wedding procession – a classical tribute to the newly married royal couple – which the title also suggests. Alma-Tadema developed and aggrandised this subject in his next painting, the large *Spring* (Los Angeles, California, J. Paul Getty Museum) where the recipient is clearly shown as in a procession. C.N.

39
God Speed
Sir Lawrence Alma-Tadema,
b. Dronrijp (Leeuwarden) 1836,
d. Wiesbaden 1912
Oil on wooden panel, 25.1 × 13.7 cm
Signed, and inscribed: *Op. CCCXXII*

LITERATURE
Dircks 1910, p. 31
Swanson 1990, pp. 248–9

EXHIBITIONS
London, Imperial Institute, 1893,
 Exhibition of Wedding Presents
 of TRH The Duke and Duchess
 of York, no. 1202
Birmingham, Royal Society of
 Artists, 1896, no. 373
Dublin, Irish International
 Exhibition, 1907, no. 144
London, Royal Academy Winter
 Exhibition, 1913, no. 94

VALENTINE CAMERON PRINSEP (1838–1904)

Two Ladies on a Staircase

Probably painted in 1873, this picture had entered the collection of the Prince and Princess of Wales by 1877, when it is recorded as hanging in Buckingham Palace. After an artistic training with George Frederick Watts and Edward Burne-Jones, Prinsep became an established figure in the London artistic scene and a member of the Little Holland House group. Prominent in social circles and a close friend of Lord Leighton (see p. 106), Prinsep had a mature style that was influenced by John Everett Millais and Sir Luke Fildes (see p. 112). He was an exhibitor at the Royal Academy between 1862 and 1904 and became Professor of Painting between 1900 and 1903. Although Prinsep lacked artistic originality, his personal charm and social standing gained him an important position in the Victorian art world.

This picture has recently been identified with the painting entitled *Devonshire House*, exhibited at the Royal Academy in 1873 and subsequently engraved. It was greatly admired by critics and seen by the young Vincent Van Gogh, who described it as 'a very clever picture'. The picture shows two ladies on the so-called 'crystal staircase' at Devonshire House, Piccadilly, the London home of the Dukes of Devonshire. The house, which had been designed by William Kent in 1734, was refurbished by the architect Decimus Burton in the 1840s for the fourth Duke. The new circular staircase had a glass handrail and glass newel at its foot, rising up to the 'great drawing-room' on the first floor in a sweeping curve. It is recorded in photographs taken before the house was demolished in 1920.

Devonshire House was regularly used for entertaining by the eighth Duke of Devonshire, Spencer Compton Cavendish (1833–1908), a friend of Edward, Prince of Wales, and Princess Alexandra – who both attended balls and celebrations there. It is possible that this picture represents one such occasion and was purchased by the Prince as a memento of past times. The two ladies on the crystal staircase may be members of the Cavendish family, but they have yet to be identified. In this vignette, encapsulating the luxury of late Victorian aristocratic life, the artist has clearly taken pleasure in depicting the complexity of the women's bustled dresses as they stop on the stairs to gaze at the scene below. K.B.

40
*Two Ladies on a Staircase, c.*1873
Valentine Cameron Prinsep,
b. Calcutta 1838, d. London 1904
Oil on canvas, 45.7 × 30.8 cm

LITERATURE
Sykes 1985, p. 270
Millar 1992, no. 563

EXHIBITIONS
London, South London Art Gallery,
 1977, no. 31
London, Barbican Art Gallery,
 1992, no. 79

SIR (SAMUEL) LUKE FILDES (1843–1927)

King George V

A study, probably a *modello*, for the State Portrait of George V, which was commissioned in 1911 and first hung at Windsor Castle. It was acquired by The Queen in 1973.

Sir Luke Fildes was a conservative choice of artist for the King's State Portrait. A Liverpudlian Royal Academician, he was a successful portraitist who had started his career as an illustrator and painter of social-realist scenes. In the 1880s he turned to portraiture, in the next decade painting both the Princess of Wales and the newly engaged Duke and Duchess of York (later George V and Queen Mary). In 1902 he was chosen to paint the State Portrait of Edward VII. George V, justifying his own choice of Fildes, commented, 'I liked very much what Sir Luke did of my father, ... and I like Sir Luke personally, and we get on very well together.'

On 11th April 1911 Fildes agreed to paint the State Portrait for £1,000. Despite the friendship between artist and patron, this important commission became dogged with difficulties. The portrait was expected at the 1912 Royal Academy exhibition. However, the King was too preoccupied with the political representation problem of the House of Lords to sit before his departure for the Delhi Durbar on 11th November; a photograph in naval uniform had to suffice. The exceptionally dark winter, together with a failure to lend the King's robes and insignia, prevented Fildes from getting on with the portrait. The return of the King Emperor in February 1912, and the improving light, finally brought progress. Special permission was granted for the portrait to be submitted late to the Royal Academy. The King sat on 19th and 25th March and on 5th May. Following his father's precedent, further sittings on 13th and 25th May took place in Fildes's home in Melbury Road. The King returned there with the Queen on 2nd June to see the finished portrait. Both were pleased and Queen Mary confided to her diary that 'it is a very good picture'.

The pose of the King goes back to the 1636 portrait of Charles I in Garter robes by Van Dyck. However, in general disposition and pose the finished portrait is a reverse image of Fildes's 1902 State Portrait of Edward VII. In the sketch, which has all the elements of the finished portrait, an additional background marble column seen also in Edward VII's State Portrait is present. The King may have inspected this *modello* on 16th or 30th March 1912 when Fildes saw him and is likely to have asked for the column's removal from the design. Swagger in the father's portrait is replaced by reserve in the son's. The sketch has a much freer, bolder handling than that of the finished portrait. C.N.

41
King George V (1865–1936)
Sir (Samuel) Luke Fildes,
b. Liverpool 1843, d. London 1927
Oil on canvas, 68.9 × 51.1 cm

LITERATURE
Fildes 1968, pp. 192–6
Lloyd 1992, p. 273, figs 181 and 182

EXHIBITION
London, The Queen's Gallery,
1982–3, no. 120

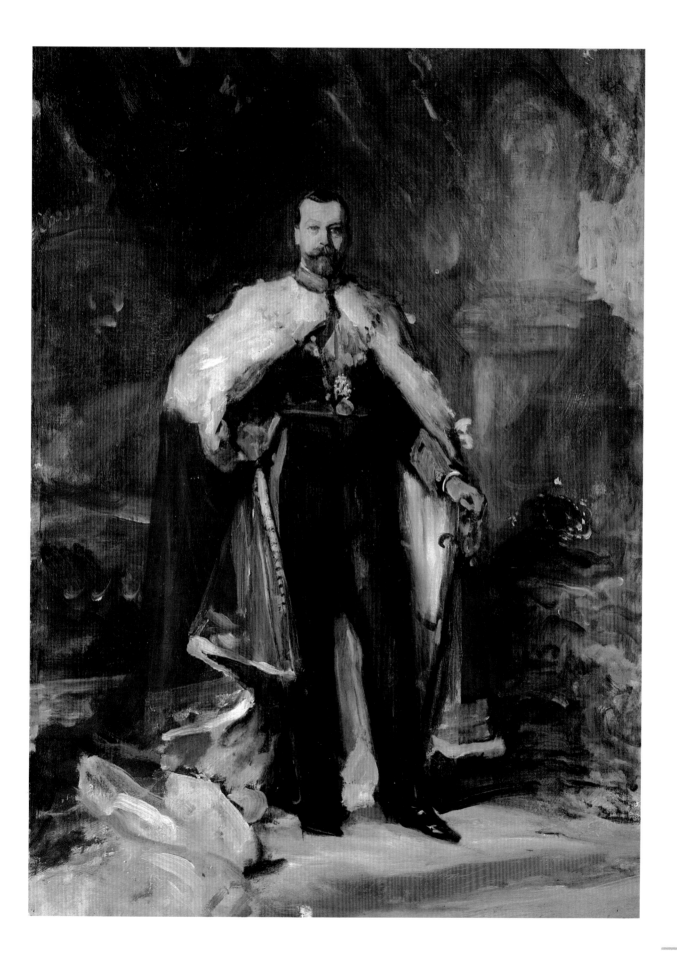

ELIZABETH THOMPSON, LADY BUTLER (1846–1933)

The Roll Call: Calling the Roll after an Engagement, Crimea

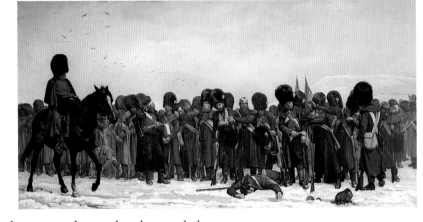

The Roll Call captured the imagination of the country when it was exhibited at the Royal Academy in 1874. It was the most popular painting shown there in the nineteenth century, and the fact that the artist was a woman aged only 27 added to its impact. A policeman had to be placed in front of the picture to control the crowds and it subsequently toured the country in triumph.

In the cold light of morning the remnants of a battalion of Grenadier Guards, many exhausted and wounded, are answering the roll call held by the sergeant before a mounted officer. Although the artist did not link the scene with a particular incident in the Crimean War (1854–6), it was assumed to represent the Battle of Inkerman – which took place in rain and fog, not snow, on 5th November 1854. Captain George Higginson was the mounted officer. In their defence of the Battery, the 3rd Battalion Grenadier Guards, totalling about 650, lost 104 officers and men with another 130 wounded. Elizabeth Butler is quoted in her obituary as saying, 'Thank God, I never painted for the glory of war, but to portray its pathos and heroism.' A patriot, not a pacifist, she chose to focus on the bravery and endurance of the ordinary British soldier. Until this date images of the Crimean War had consisted of prints, photographs and illustrations in newspapers. Probably partly derived from such sources, this simple but dramatic composition vividly epitomised the grimness of all wars. *The Roll Call* matched the mood of the times, for not only was there a general climate for social reform, but the hardships suffered by soldiers in the Crimean War had led to the institution of military reforms in the 1870s.

The artist may also have been inspired by John Bell's sculpture of the Guards' Memorial in Waterloo Place, London (1860). The influence of contemporary French military painters whom Butler admired (Jean-Louis Meissonier, Edouard Détaille and Alfonse de Neuville) is evident. Elizabeth Butler researched her subject by consulting Crimean veterans and finding relevant uniforms and equipment.

The Manchester industrialist Charles Galloway had originally commissioned the painting. The Prince of Wales was keen to buy it but so was Queen Victoria, to whom Galloway eventually ceded it. The Queen had been very concerned about the ordeals faced by the rank and file in the Crimean War, which, she noted, was won by their 'persevering valour and chivalrous devotion'. L.W.

42
The Roll Call: Calling the Roll after an Engagement, Crimea
Elizabeth Thompson, Lady Butler,
b. Lausanne 1846, d. Gormanston, Ireland 1933
Oil on canvas, 93.3 × 183.5 cm
Signed and dated: *Elizth Thompson/ 1874* (under a device comprising a cross and a capital C (?))

LITERATURE
Millar 1992, no. 185

EXHIBITIONS
London, National Army Museum, 1987, pp. 23–36, no. 18
London, National Gallery, 1991, no. 77
Wellington, Museum of New Zealand Te Papa Tongarewa, 1994–5, no. 30

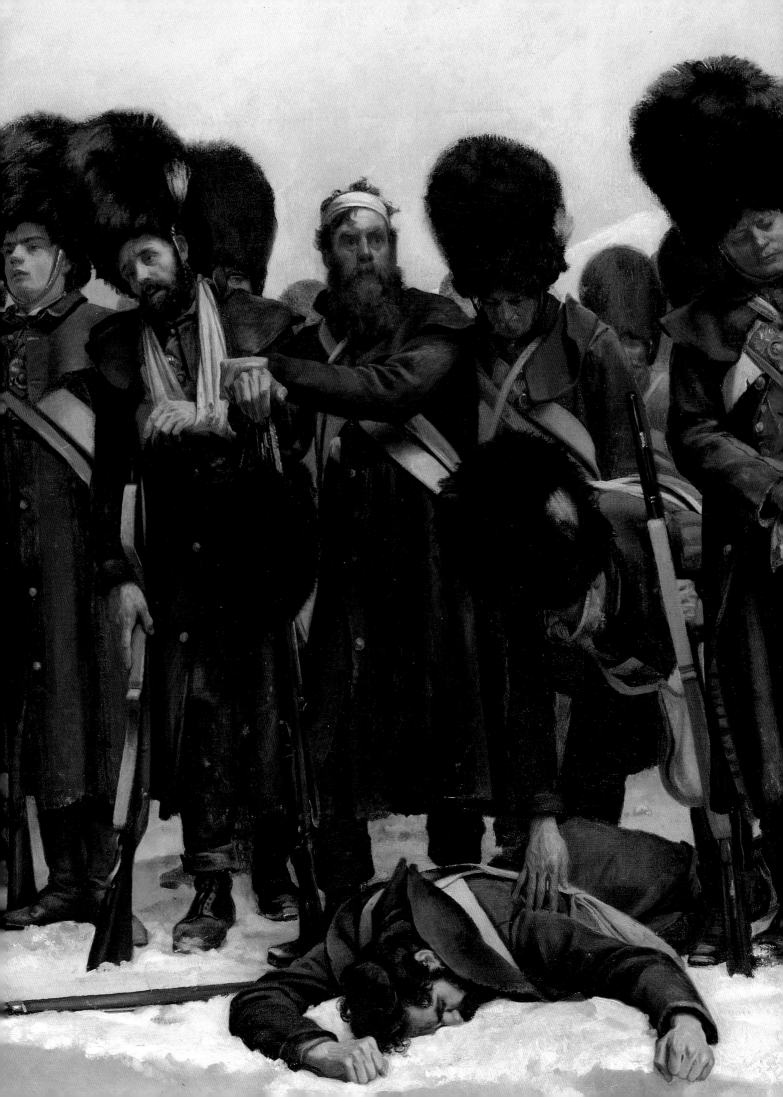

SIR JOHN LAVERY (1856–1941)

The Family of King George V: First Study

The first group study for the large family portrait which was commissioned by Hugh Spottiswoode for the National Portrait Gallery and exhibited at the Royal Academy of 1913 (no. 170). It was presented to Queen Mary by the artist that year and can be seen as a precursor of Lavery's portrait interiors of the late 1920s.

Lavery recounts in his autobiography that he received the commission in 1912. He had written in August 1911 about sittings from George V and Queen Mary. Sittings, in Buckingham Palace, were not however granted until early 1913, leaving Lavery little time before the Royal Academy exhibition. The King sat on 20th, 23rd and 25th February and 4th and 13th April 1913. Queen Mary recorded sittings on 19th, 22nd, 24th and 26th February. The King and Queen showed considerable interest in this monumental family portrait. They had suggested at the start that the only other family members to be depicted should be the Prince of Wales and Princess Mary. Lavery relates, 'The Queen expressed a wish to see my idea for the grouping, and a sketch I made was pronounced satisfactory, so I was permitted the use of the White Drawing Room as a studio.' Although the choice of this state room favoured Lavery's restricted palette, the approved sketch was not the last word. Large-scale studies of the King and Queen were made. A second group study records a change of the table on which the King rests his right hand, and a final figure study of the King has a more commanding frontal pose and dispenses with the table. Some of these changes may result from the royal family's close involvement in the portrait. Certainly the King's and Queen's visits to the artist's studio, on 9th March and 10th April, to see the portrait's progress betoken more than usual interest. Indeed, on one of these visits the King and Queen both applied royal blue paint to a Garter riband in the picture.

The final painting appears uneasy to modern eyes. Lavery records that it was commissioned to be after the manner of Franz Xaver Winterhalter's 1846 royal family picture, then as now in Buckingham Palace. However, the royal decision to leave out the younger members of the family and Prince Albert, who was at sea, deprived Lavery of depicting family intimacy and the spontaneity of young children. His figures are stiff, isolated and formal. Lavery's portrait falters between a public and private image, the symbolic and the documentary. In 1913, however, its unresolved nature may have been less noticeable, the isolated figure of the King conforming to contemporary notions of him as a 'father-figure to the whole empire, yet also in his own right the head of a family with which all could identify'.

C.N.

43
The Family of King George V: First Study
Sir John Lavery, b. Belfast 1856, d. Kilkenny 1941
Oil on canvas, 76.7 × 63.6 cm
Signed; inscribed and dated by the artist on the reverse

LITERATURE
Smith 1931, p. 155, ill. 148
Levey 1971, p. 213
Lloyd 1992, pp. 214, 288 (quoting D. Cannadine)
McConkey 1993, pp. 121–5, ill. 149

EXHIBITION
London, Mall Galleries, 1991, no. 18
Edinburgh, The Fine Art Society, 1984

SIR JOHN LAVERY (1856–1941)

The Family of King George V: Study of Princess Mary

A single-figure study of Princess Mary for the large royal family portrait in the National Portrait Gallery. Together with a similar study of the Prince of Wales, it was presented to Queen Mary by the artist in 1913.

Lavery made four initial single-figure studies for his royal family group portrait: two large ones of the King and Queen, and two smaller ones of the Prince of Wales and Princess Mary. The studies of the King and Queen, also presented by Lavery in 1913, were worked up into independent portraits and widely exhibited. Those of the Prince of Wales and Princess Mary were originally the size of the two group studies but have been slightly reduced.

From Lavery's inscription on this study, Princess Mary must have sat to him in Buckingham Palace in February 1913. She did not record the sittings in her diary, but it is likely that she gave several sittings, as did her brother. The Prince of Wales gave two sittings in March of two and one-and-a-half hours; 'Awful waste of time,' he commented in his diary. The relaxed figure of the seated Princess is important for the finished portrait both compositionally and as a counterpart to the other stiff, upright figures.

Princess Mary, the only daughter of George V and Queen Mary, was born and brought up at Sandringham House. Educated by governesses, she became fluent in French and German. She greatly enjoyed the outdoor life, acquiring an enduring love of horses and skill in riding. She was later to be painted on horseback by Sir Alfred Munnings.

Of a gentle disposition, the Princess had a beautiful complexion but was often unwell. Lady Maud Baillie, daughter of the ninth Duke of Devonshire and a fellow pupil before the First World War, recorded, 'Princess Mary and I were not great scholars. She was generally miserable with hay fever and terrified of her governess, who sat knitting fiercely, like Mme Defarge.' Lady Maud also believed Princess Mary had very limited contact with other children. The Prince of Wales constantly complained to the Queen of his sister's secluded and lonely life; more practically, he suggested possible suitors.

Queen Mary however had her own plans for her daughter's future, wishing her to be married to Prince Ernst August of Hanover, a direct male descendant of George III. It was not to be, for in 1913 Prince Ernst married the German Emperor's daughter. The First World War put paid to further German marital plans, and the Princess married in 1922 Viscount Lascelles, later sixth Earl of Harewood. George V, greatly saddened by his daughter's departure, commissioned a large painting by Frank Salisbury of her marriage in Westminster Abbey. Lavery painted her wedding procession in Green Park. C.N.

44
The Family of King George V: Study of Princess Mary (later Princess Royal, Countess of Harewood) (1897–1965)
Sir John Lavery, b. Belfast 1856, d. Kilkenny 1941
Oil on canvas, 76.2 × 53.5 cm
Inscribed, signed, and dated: *February 1913*

LITERATURE
Rose 1985, pp. 193–5
Baillie 1989, pp. 16, 37
Ziegler 1990, pp. 79–80

H.R.H. PRINCESS
MARY

BUCKINGHAM PALACE
FEBRUARY 1915

119

SIR JOHN LAVERY (1856–1941)

Air Station, North Queensferry

This war picture is a rare example of a modernist British painting in George V's collection. It was a Silver Wedding present to the King and Queen Mary on 6th July 1918 from members of the royal family. The painting was purchased by Prince Arthur, Duke of Connaught, for 75 guineas on behalf of his four surviving sisters. A month earlier he had written to Princess Louise, 'I have found a very interesting and cleverly painted war picture by Sir John Lavery which I am sure they will like; it has been difficult to find a good modern picture by a well known artist at a moderate price'.

The King's reaction to this enlightened choice of gift is unrecorded. Both King and artist made numerous wartime visits to the Grand Fleet, based in the Firth of Forth and at Scapa Flow. In June 1917 the King devoted a week to its inspection. Lavery, then 61 years old, was an official war artist restricted to the Home Front, travelling widely to record naval activities. Some dozen canvases resulted from Lavery's fortnight's stay in Edinburgh in September 1917, depicting principally the Grand Fleet, the Forth Bridge and local military installations.

Air Station, North Queensferry shows the temporary airfield east of Rosyth, which had been recently transferred by the Royal Flying Corps to the Royal Naval Air Service. It was established to support the warships of the Grand Fleet, and both kite balloons and later aircraft were based there. The kite balloons, inflated on site, were towed out by lighter to the warships and attached to the quarterdeck. Used by battleships, battlecruisers and cruisers, they improved the range at which the enemy could be sighted. Lavery's picture, although freshly and fluidly painted, is likely to have been worked on in his London studio as it was not ready for inspection by the Chief Naval Censor in November 1917. The reverse of the canvas still bears the censor's red paint inscriptions.

Despite his frustrations at being kept from the Front, Lavery's search for subjects extended the range of the war artist. He was one of the first artists to take to the air, in August 1918, making studies from an airship for a picture of a North Sea convoy. Earlier that year, recently knighted, he braved Arctic conditions in a heated airman's suit to make swift sketches of Scapa Flow. He donated the majority of his naval war pictures to the Imperial War Museum in 1918. Deeply supportive of younger war artists, Lavery denigrated his own wartime achievement, stating, 'I felt nothing of the stark reality, losing sight of my fellow men being blown to pieces in submarines, or slowly choking to death in mud. I saw only new beauties of colour and design.' C.N.

45
Air Station, North Queensferry, 1917
Sir John Lavery, b. Belfast 1856,
d. Kilkenny 1941
Oil on canvas, 63.5 × 76.6 cm
Signed; inscribed and dated on the
reverse by the artist: *1917*

LITERATURE
Lavery 1940, pp. 145, 149–50
McConkey 1993, pp. 136–42

SIR GERALD KELLY (1879–1972)

Study of the Imperial State Crown

The painting was one of numerous studies made in connection with the State Portraits of King George VI and Queen Elizabeth. The Imperial State Crown appears set on a cushion on a table beside the King at the right edge of the finished composition. Kelly later recorded that he spent 'day after day' painting the Crown in preparation for the portrait. Many of the studies, including the present one, were in the sale of the artist's studio contents held at Christie's on 8th February 1980 (lots 240–52). Of these the still-life studies are amongst the most striking.

Kelly had no formal training in art, but spent some time in Paris during his formative years. Apart from making a journey to Burma (1908) and a world tour (1935–6), both of which appealed to his taste for the exotic, Kelly was a disciplined portrait painter. The key to his reputation was careful preparation, meticulous drawing and a refined sense of colour. He was elected President of the Royal Academy in 1949.

The commission to paint the State Portraits was suggested in 1938 by Kenneth (later Lord) Clark on the basis that Kelly was 'the most reliable portrait painter of his time'. Although he began the project before the Second World War, the artist undertook most of the work at Windsor Castle, where he resided for the duration. The finished portraits were shown at the Royal Academy in 1945 (nos 156 and 159). A full account of the commission is given in the biography of the artist written by Derek Hudson, *For Love of Painting. The Life of Sir Gerald Kelly* (1975), chapter VI. The presence of the artist at Windsor Castle during the war years prompted some comment and Sir Alan Lascelles (Private Secretary to King George VI and Queen Elizabeth II in turn) in his journal opined humorously that 'Gerald, like Penelope, got up at night to undo the work he had done during the day'.

State Portraits are a formidable challenge for the modern painter and Kelly encountered difficulties over pose, setting and dress. The outcome, however, was a success, with the audacious scale, the handling of perspective and the subtlety of lighting being particularly notable. For the backgrounds Kelly asked Sir Edwin Lutyens to make models for him suggestive of the Viceroy's House at Delhi. A pupil, John Napper (b. 1916) assisted Kelly at the outset.

The State Portraits hang in the Crimson Drawing Room at Windsor Castle.

C.L.

46
Study of the Imperial State Crown
Sir Gerald Kelly, b. London 1879,
d. London 1972
Oil on millboard, 46.7 × 39.1 cm

EXHIBITION
London, The Queen's Gallery,
1982–3, no. 131

GENEALOGICAL TREE

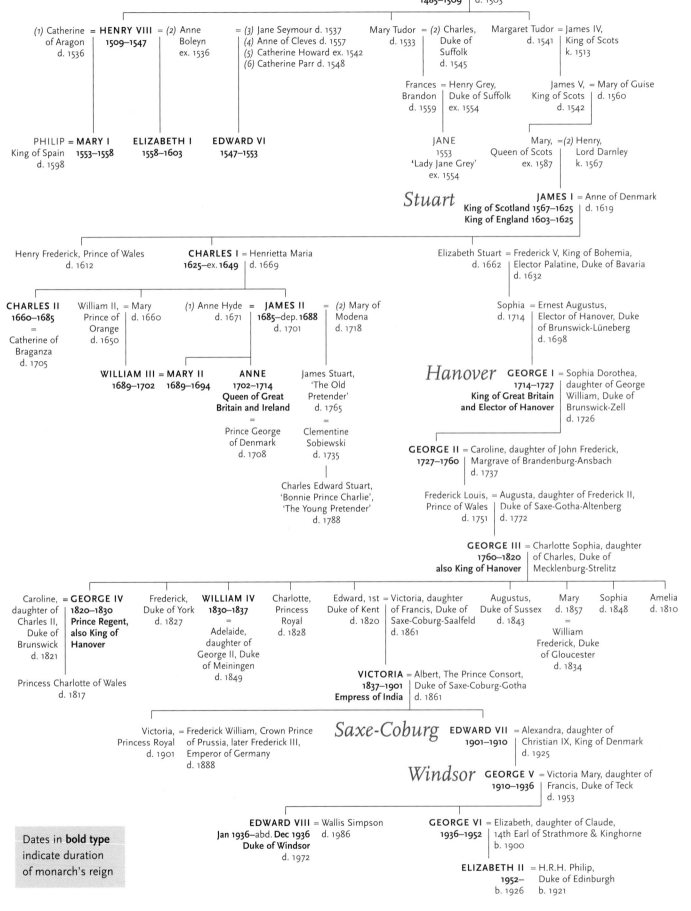

Tudor

HENRY VII = Elizabeth of York
1485–1509 | d. 1503

(1) Catherine = HENRY VIII = (2) Anne
of Aragon 1509–1547 Boleyn
d. 1536 ex. 1536

= (3) Jane Seymour d. 1537
(4) Anne of Cleves d. 1557
(5) Catherine Howard ex. 1542
(6) Catherine Parr d. 1548

Mary Tudor = (2) Charles,
d. 1533 Duke of Suffolk
d. 1545

Margaret Tudor = James IV,
d. 1541 | King of Scots
k. 1513

Frances = Henry Grey,
Brandon Duke of Suffolk
d. 1559 ex. 1554

James V, = Mary of Guise
King of Scots d. 1560
d. 1542

PHILIP = MARY I
King of Spain 1553–1558
d. 1598

ELIZABETH I
1558–1603

EDWARD VI
1547–1553

JANE
1553
'Lady Jane Grey'
ex. 1554

Mary, = (2) Henry,
Queen of Scots Lord Darnley
ex. 1587 k. 1567

Stuart

JAMES I = Anne of Denmark
King of Scotland 1567–1625 | d. 1619
King of England 1603–1625

Henry Frederick, Prince of Wales
d. 1612

CHARLES I = Henrietta Maria
1625–ex. 1649 | d. 1669

Elizabeth Stuart = Frederick V, King of Bohemia,
d. 1662 | Elector Palatine, Duke of Bavaria
d. 1632

Sophia = Ernest Augustus,
d. 1714 | Elector of Hanover, Duke
of Brunswick-Lüneberg
d. 1698

CHARLES II
1660–1685
=
Catherine of
Braganza
d. 1705

William II, = Mary
Prince of d. 1660
Orange
d. 1650

(1) Anne Hyde = JAMES II = (2) Mary of
d. 1671 1685–dep. 1688 Modena
d. 1701 d. 1718

WILLIAM III = MARY II
1689–1702 1689–1694

ANNE
1702–1714
**Queen of Great
Britain and Ireland**
=
Prince George
of Denmark
d. 1708

James Stuart,
'The Old
Pretender'
d. 1765
=
Clementine
Sobiewski
d. 1735

Hanover

GEORGE I = Sophia Dorothea,
1714–1727 | daughter of George
King of Great Britain William, Duke of
and Elector of Hanover Brunswick-Zell
d. 1726

GEORGE II = Caroline, daughter of John Frederick,
1727–1760 | Margrave of Brandenburg-Ansbach
d. 1737

Charles Edward Stuart,
'Bonnie Prince Charlie',
'The Young Pretender'
d. 1788

Frederick Louis, = Augusta, daughter of Frederick II,
Prince of Wales | Duke of Saxe-Gotha-Altenberg
d. 1751 | d. 1772

GEORGE III = Charlotte Sophia, daughter
1760–1820 | of Charles, Duke of
also King of Hanover Mecklenburg-Strelitz

Caroline, = GEORGE IV
daughter of 1820–1830
Charles II, **Prince Regent,**
Duke of **also King of**
Brunswick **Hanover**
d. 1821

Princess Charlotte of Wales
d. 1817

Frederick,
Duke of York
d. 1827

WILLIAM IV
1830–1837
=
Adelaide,
daughter of
George II, Duke
of Meiningen
d. 1849

Charlotte,
Princess
Royal
d. 1828

Edward, 1st = Victoria, daughter
Duke of Kent of Francis, Duke of
d. 1820 Saxe-Coburg-Saalfeld
d. 1861

Augustus,
Duke of Sussex
d. 1843

Mary
d. 1857
=
William
Frederick, Duke
of Gloucester
d. 1834

Sophia
d. 1848

Amelia
d. 1810

VICTORIA = Albert, The Prince Consort,
1837–1901 | Duke of Saxe-Coburg-Gotha
Empress of India d. 1861

Victoria, = Frederick William, Crown Prince
Princess Royal of Prussia, later Frederick III,
d. 1901 Emperor of Germany
d. 1888

Saxe-Coburg

EDWARD VII = Alexandra, daughter of
1901–1910 | Christian IX, King of Denmark
d. 1925

Windsor

GEORGE V = Victoria Mary, daughter of
1910–1936 | Francis, Duke of Teck
d. 1953

EDWARD VIII = Wallis Simpson
Jan 1936–abd. Dec 1936 d. 1986
Duke of Windsor
d. 1972

GEORGE VI = Elizabeth, daughter of Claude,
1936–1952 | 14th Earl of Strathmore & Kinghorne
b. 1900

ELIZABETH II = H.R.H. Philip,
1952– Duke of Edinburgh
b. 1926 b. 1921

Dates in **bold type**
indicate duration
of monarch's reign

124

BIBLIOGRAPHY

Altick 1985 R. D. Altick, *Painting from Books, Art and Literature in Britain, 1760–1900*, Columbus, 1985

Baillie 1989 M. Baillie, 'Early Memories', n.p., 1989

Beevers 1997 R. Beevers, 'George Sanders and the Byronic Image', *Apollo*, 1997, CXLVI, 427, pp. 37–42

Bermingham 1987 A. Bermingham, *Landscape and Ideology: The English Rustic Tradition 1740–1860*, London, 1987

Brown 1982 C. Brown, *Van Dyck*, Oxford, 1982

Clifton 1995 G. Clifton, *Directory of British Scientific Instrument Makers 1550–1851*, London, 1995

Cormack 1991 M. Cormack, *The Paintings of Thomas Gainsborough*, Cambridge, 1991

Cowling 1989 M. Cowling, *The Artist as Anthropologist*, Cambridge, 1989

Cunningham 1843 A. Cunningham, *The Life of David Wilkie with His Journals, Tours & Critical Remarks on Works of Art and a Selection from his Correspondence*, 3 vols, London, 1843

De-la-Noy 1996 M. De-la-Noy, *The King who never Was, The Story of Frederick, Prince of Wales*, London and Chester Springs PA, 1996

Dircks 1910 R. Dircks, *The Later Works of Sir Lawrence Alma-Tadema*, London, 1910 (suppl. to *The Art Journal*, Dec. 1910)

Dorment 1986 R. Dorment, *British Painting in the Philadelphia Museum of Art*, London, 1986

Douglas Stewart 1983 J. Douglas Stewart, *Sir Godfrey Kneller and the English Baroque Portrait*, Oxford, 1983

Fildes 1968 F. L. V. Fildes, *Luke Fildes R.A. A Victorian Painter*, London, 1968

Fraser 1996 F. Fraser, *The Unruly Queen The Life of Queen Caroline*, London, 1996

Frith 1887 N. Frith, *Autobiography and Reminiscences*, 2 vols, London, 1887

Fussell 1974 G. Fussell, *James Ward RA, Animal Painter 1769–1859 and his England*, London, 1974

Ganz 1956 P. Ganz, *The Paintings of Hans Holbein*, Oxford, 1956

Garlick 1989 K. Garlick, *Sir Thomas Lawrence*, Oxford, 1989

Goodison 1969 N. Goodison, *English Barometers 1680–1860*, London, 1969

Hayes 1970 J. Hayes, *The Drawings of Thomas Gainsborough*, London, 1970

Hayes 1982 J. Hayes, *Gainsborough's Landscape Paintings*, 2 vols, London, 1982

Heaton 1880 C. Heaton, *The Lives of the Most Eminent Painters by Allan Cunningham Annotated and Continued to the Present Time by Mrs Charles Heaton*, 3 vols, London, 1880

Heleniak 1980 K. M. Heleniak, *William Mulready*, New Haven and London, 1980

James 1966 O. James (ed.), *A Shakespeare Encyclopedia*, London, 1966

Johnson 1986 E. D. H. Johnson, *Paintings of the British Social Scene from Hogarth to Sickert*, London, 1986

Kalinsky 1995 N. Kalinsky, *Gainsborough*, London, 1995

Larsen 1988 E. Larsen, *The Paintings of Anthony van Dyck*, 2 vols, Freren, 1988

Lavery 1940 J. Lavery, *The Life of a Painter*, London, 1940

Levey 1971 M. Levey, *Painting at Court*, London, 1971

Lloyd 1992 C. Lloyd, *The Royal Collection*, London, 1992

McConkey 1993 K. McConkey, *Sir John Lavery*, Edinburgh, 1993

McKay and Roberts 1909 W. McKay and W. Roberts, *John Hoppner RA*, London, 1909

Millar 1985 D. Millar, *Queen Victoria's Life in the Scottish Highlands Depicted by her Watercolour Artists*, London, 1985

Millar 1963 O. Millar, *The Tudor, Stuart and Early Georgian Pictures in the Collection of Her Majesty The Queen*, 2 vols, London, 1963

Millar 1969 O. Millar, *The Later Georgian Pictures in the Collection of Her Majesty The Queen*, 2 vols, London, 1969

Millar 1977 O. Millar, *The Queen's Pictures*, London, 1977

Millar 1992 O. Millar, *The Victorian Pictures in the Collection of Her Majesty The Queen*, 2 vols, Cambridge, 1992

Parry 1981 G. Parry, *The Golden Age Restor'd: The Culture of the Stuart Court, 1603–42*, Manchester, 1981

Patten 1992 R. L. Patten, *George Cruikshank's Life, Times, and Art*, 2 vols, London, 1992

Paulson 1975 R. Paulson, *Emblem and Expression: Meaning in English Art of the Eighteenth Century*, London, 1975

Paulson 1992 R. Paulson, *Hogarth, The 'Modern Moral Subject'*, I, Cambridge, 1992

Peach 1993 A. Peach, '"San Fedele Alla Mia Biondetta": A Portrait of Lord Byron Formerly Belonging to Lady Caroline Lamb', *Bodleian Library Record*, 14, 1993, pp. 285–95

Pointon 1979 M. Pointon, *William Dyce 1806–1864*, Oxford, 1979

Postle 1995 M. Postle, *Sir Joshua Reynolds The Subject Pictures*, Cambridge, 1995

Raines 1967 R. Raines, *Marcellus Laroon*, London, 1967

Rose 1985 K. Rose, *Kings, Queens & Courtiers*, London, 1985

Rosenthal 1992 M. Rosenthal, 'Gainsborough's *Diana and Actaeon*' in *Painting and the Politics of Culture, New Essays on British Art 1700–1850*, ed. J. Barrell, Oxford and New York, 1992

Rowlands 1985 J. Rowlands, *Holbein*, Oxford, 1985

Smart 1992 A. Smart, *Allan Ramsay: Painter, Essayist and Man of the Enlightenment*, New Haven and London, 1992

Smith 1931 C. Smith, *Buckingham Palace*, London, 1931

Sotheby's 1996 Sotheby's, Wednesday, 3rd April 1996, *Eighteenth and Nineteenth Century British Drawings and Watercolours*, London, 1996

Strong 1972 R. Strong, *Van Dyck: Charles I on Horseback*, London, 1972

Swanson 1990 V. G. Swanson, *The Biography and Catalogue Raisonné of the Paintings of Sir Lawrence Alma-Tadema, O.M., R.A.*, London, 1990

Sykes 1985 C. Sykes, *Private Palaces. Life in the Great London Houses*, London, 1985

Taylor 1853 T. Taylor (ed.), *Life of Benjamin Robert Haydon*, London, 1853

Uhry Adams 1985 A. Uhry Adams, *The Valiant Hero. Benjamin West and the Grand Style of History Painting*, Washington DC, 1985

Vaughan 1979 W. Vaughan, *German Romanticism and English Art*, New Haven and London, 1979

Von Effra and Staley 1986 H. von Effra and A. Staley, *The Paintings of Benjamin West*, New Haven and London, 1986

Woodward 1957 J. Woodward, 'Amigoni as Portrait Painter in England', *Burlington Magazine*, XCIX, 1957, pp. 21–3

Ziegler 1990 P. Ziegler, *King Edward VIII*, London, 1990

EXHIBITIONS

A published catalogue accompanied each exhibition listed.

Aldeburgh, Aldeburgh Festival, 1967 *Marcellus Laroon*; also at the Tate Gallery, London

London, Tate Gallery, 1971–2 *Hogarth*

London, National Portrait Gallery and Dublin, National Gallery of Ireland, 1972 *Daniel Maclise*

London, Tate Gallery, 1972–3 *The Age of Charles I, Painting in England 1620–1649*

London, Hayward Gallery, 1974 *British Sporting Painting 1650–1850*; also at the Leicestershire Museum and Art Gallery, Leicester, and the Walker Art Gallery, Liverpool

London, Victoria and Albert Museum, 1974 *Byron*

London, National Portrait Gallery, 1976 *Johann Zoffany*

London, Kenwood House, 1977 *Nathaniel Dance 1735–1811*

London, The Queen's Gallery, 1977 *Silver Jubilee Exhibition. The Queen's Pictures, The Story of the Royal Collection*

London, South London Art Gallery, 1977 *Val Prinsep RA (1838–1904), A Jubilee Painter*

London, The Queen's Gallery, 1978–9 *Holbein and the Court of Henry VIII*

London, National Portrait Gallery, 1979 *Sir Peter Lely 1618–1680*

London, Tate Gallery, 1980–1 *Thomas Gainsborough*

Sudbury, Gainsborough's House, 1981 *Frederick, Prince of Wales and his Circle*

Philadelphia, Philadelphia Museum of Art and London, Tate Gallery, 1981–2 *Sir Edwin Landseer*

Edinburgh, Scottish National Portrait Gallery, 1982 *John Michael Wright 'The King's Painter'*

London, National Portrait Gallery, 1982–3 *Van Dyck in England*

London, The Queen's Gallery, 1982–3 *Kings and Queens*

Washington, National Gallery of Art, 1983 *Gainsborough's Drawings*; also at the Kimbell Art Gallery, Fort Worth, and the Yale Center for British Art, New Haven

Edinburgh, The Fine Art Society, 1984 *Sir John Lavery R.A. 1856–1941*; also at the Fine Art Society, London; the Ulster Museum, Belfast; the National Gallery of Ireland, Dublin; 1984–5

London, Tate Gallery, 1984 *George Stubbs 1724–1806*

Edinburgh, National Gallery of Scotland, 1985 *Tribute to Wilkie*

Oxford, Ashmolean Museum, 1985 *Sir David Wilkie Drawings and Sketches in the Ashmolean Museum*; also at Morton Morris and Company Ltd, London

Edinburgh, The Talbot Rice Centre, University of Edinburgh and London, Tate Gallery, 1986 *Painting in Scotland The Golden Age*

London, Royal Academy, 1986 *Reynolds*; also at the Grand Palais, Paris, 1985–6

London, Victoria and Albert Museum, 1986 *Mulready*; also at the National Gallery of Ireland, Dublin

London, Museum of London, 1987 *Londoners*

London, National Army Museum, 1987 *Lady Butler Battle Artist 1846–1933*; also at the Durham Light Infantry Museum and Arts Centre and the Leeds City Art Gallery, 1987–8

Raleigh, North Carolina Museum of Art, 1987 *Sir David Wilkie of Scotland (1785–1841)*

London, Tate Gallery, 1987–8 *Manners and Morals. Hogarth and British Painting 1700–1760*

London, The Queen's Gallery, 1988–9 *Treasures from the Royal Collection*

Baltimore, Baltimore Museum of Art, 1989 *Benjamin West. An American Painter at the English Court*

Edinburgh, Scottish National Portrait Gallery, 1989 *Patrons and Painters in Scotland*

Cardiff, National Museum of Wales, 1990–1 *The Royal Collection: Paintings from Windsor Castle*

Washington, National Gallery of Art, 1990–1 *Anthony van Dyck*

Greenwich, National Maritime Museum, 1991 *Henry VIII, A European Court in England*

London, Mall Galleries, 1991 *Royal Society of Portrait Painters Centenary Exhibition*

London, National Gallery, 1991 *The Queen's Pictures. Royal Collectors through the Centuries*

Essen, Villa Hugel, 1992 *London – World City 1800–1840*

London, Barbican Art Gallery, 1992 *Van Gogh in England: Portrait of the Artist as a Young Man*

London, Tate Gallery, 1992 *Turner and Byron*

Plymouth, Plymouth City Museums and Art Gallery, 1992 *Sir Joshua Reynolds PRA (1723–1792) The Self Portraits*; also at Gainsborough's House, Sudbury

Edinburgh, Scottish National Portrait Gallery and London, National Portrait Gallery, 1992–3 *Allan Ramsay 1713–1784*

London, Museum of the Order of St John, Clerkenwell, 1992–3 *An Exhibition to Celebrate the Bicentenary of George Cruikshank*; also at the Towneley Hall Art Gallery and Museums, Burnley; Maidstone Museum and Art Gallery; Graves Art Gallery, Sheffield

London, The Queen's Gallery, 1994 *Gainsborough and Reynolds, Contrasts in Royal Patronage*

Wellington, Museum of New Zealand Te Papa Tongarewa, 1994–5 *The Queen's Pictures Old Masters from The Royal Collection*; also at the National Gallery of Australia, Canberra, and the National Gallery of Canada, Ottawa

London, Kenwood House, 1995 *Mrs Jordan, The Duchess of Drury Lane*

London, Royal Academy, 1996 *Frederic Leighton 1830–1896*

The Wordsworth Trust, Dove Cottage, 1996 *Benjamin Robert Haydon, Painter and Writer, Friend of Wordsworth and Keats*

York, Fairfax House, 1996 *Come Drink the Bowl Dry. Alcoholic Liquors and their Place in 18th Century Society*

London, Courtauld Institute, 1997 *Sir William Chambers, Architect to George III*

London, Royal Academy, 1997–8 *Victorian Fairy Painting*; also at the University of Iowa Museum of Art, Iowa City, and the Art Gallery of Ontario, Toronto

INDEX

Overleaf: William Hogarth, Frontispiece to an exhibition catalogue for the Society of Artists, 1761. Engraving. Royal Collection

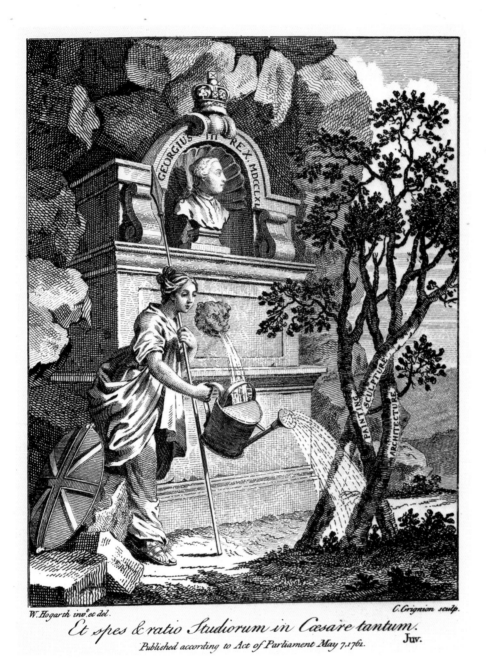

W. Hogarth inv.t et del. C.Grignion sculp.

Et spes & ratio Studiorum in Cæsare tantum.

Juv.

Published according to Act of Parliament May 7.1761.